INSPIRED ORIGAMI

PROJECTS TO CALM THE MIND
AND SOOTHE THE SOUL

John Morin and Camilla Sanderson

RUNNING PRESS
PHILADELPHIA

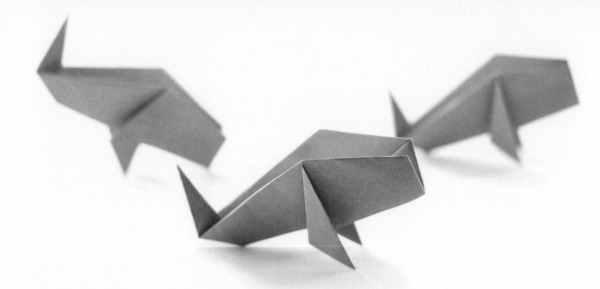

This book is dedicated to my two beautiful daughters, Lydia and Anna. —JM

Published by Running Press,
An Imprint of Perseus Books, LLC.,
A Subsidiary of Hachette Book Group, Inc.

Printed in China

Books published by Running Press are available at special discounts for
bulk purchases in the United States by corporations, institutions, and other
organizations. For more information, please contact the Special Markets
Department at Perseus Books, 2300 Chestnut Street, Suite 200,
Philadelphia, PA 19103, or call (800) 810-4145, ext. 5000, or e-mail
special.markets@perseusbooks.com.

ISBN 978-0-7624-6175-2
Library of Congress Control Number: 2016954810

9 8 7 6 5 4 3 2 1
Digit on the right indicates the number of this printing

Edited by Shannon Lee Connors
Designed by Susan Van Horn
Step illustrations by Jack Crane
Origami model construction by Peter Marchetti
Paper pattern illustrations by Bailey Watro
Typography: Verlag and V-hand

Running Press Book Publishers
2300 Chestnut Street
Philadelphia, PA 19103-4371

Visit us on the web!
www.runningpress.com

contents

introduction

The many benefits of mindfulness—for the body, mind, and spirit—were first measured in a Western medical setting in the 1970s, through the pioneering initiatives of Dr. Jon Kabat-Zinn. Through Dr. Kabat-Zinn's work we learn that "Mindfulness is awareness, cultivated by paying attention in a sustained and particular way: on purpose, in the present moment, and non-judgmentally." Any activity that helps us keep our attention in the present moment with awareness and intention, and without judgment, can be a practice in mindfulness. Origami is no exception.

Robert Lang, a physicist, author, and world-renowned American origami artist, has been an unknowing practitioner of origami-as-mindfulness since he was a child. In 1967, when he was six years old, a teacher gave Lang an origami book to keep him occupied in a math class. He was hooked and continued the practice of folding paper, finding it to be a stress reliever. Lang later went on to college at the California Institute of Technology, where he studied electrical engineering. "Caltech was very hard, very intense," he told Susan Orlean in a 2007 *New Yorker* interview. "So I did more origami. It was a release from the pressure of school."

The word "origami" is Japanese, from the words *ori*, to fold, and *kami*, paper. The principle of origami is simple: three-dimensional shapes are made from folding a single square of paper, without scissor cuts or glue. This straightforward practice has taken on great cultural significance throughout the world. In one ancient Japanese legend, for example, anyone who folds one thousand origami cranes will be granted a wish. This tradition was popularized in the West by the 1977 children's book *Sadako and the Thousand Paper Cranes* by Eleanor Coerr—a fictional retelling of the true story of Sadako Sasaki, who was diagnosed with leukemia after living through the bombing of Hiroshima. Sadako was told she had only a year to live and spent her time folding origami paper cranes, in hopes of making one thousand of them before she died. This is also an example of a mindfulness practice. Knowing death was imminent, Sadako folded origami paper cranes, which kept her awareness and attention in the present moment. This echoes an old Zen proverb that says to keep death on your shoulder to help you stay in the present moment, which is the essence of mindfulness—to keep our awareness in the here and now.

To consciously bring the practice of mindfulness into your origami art, set a gratitude intention before you begin folding each project: "Thank you for the awareness of keeping my attention in the present moment while I practice the art of origami." While you're folding paper, continually bring your attention back to your breath as a means of incorporating meditative mindfulness into your practice.

Continue to observe your breath, inhaling and exhaling. At some point you may notice that your thoughts have drifted elsewhere. If you notice that your thoughts have drifted, bring your awareness back to your breath and your paper folding; do so with kindness, compassion, and no judgment. A good analogy is when we train a puppy to pee on a mat—we don't want to be mean to the puppy, we just want to continually bring it back to the mat, and give it lots of love and encouragement. We want to bring our awareness back to the present moment in the same way. We're seeking to create an atmosphere in our minds of kindness and compassion, rather than one of perfectionism and shame.

I invite you to read more about the many benefits of mindfulness, along with some simple mindfulness practices, in my book, *The Mini Book of Mindfulness*.

May your paper folding enhance your mindfulness practice!

—Camilla Sanderson

THE HISTORY OF ORIGAMI AND PAPER

BEFORE THE ADVENT OF PAPER, PAPYRUS AND PARCHMENT WERE USED AS WRITING MATERIALS. *Papyrus, made from the papyrus plant that grew along the banks of the Nile River, was cut, beaten, and then smoothed by a stone. Its limited accessibility, however, made it an impractical material outside of ancient Egypt. In 190 BCE, people began using parchment to supplement Egyptian papyrus. A process of tanning and bleaching animal hides created a writing surface that proved superior and more durable than papyrus. However, parchment or vellum (calfskin parchment) was expensive and impractical to mass-produce. From one animal skin, you could only obtain a few sheets of parchment. A more practical writing surface was still needed.*

Paper is made by pounding wood or cloth until the fibers separate from one another. The beaten fibers are then mixed with water to form pulp. The water loosens the fibers in the wood or cloth, allowing them to be reshaped into a sheet of paper. A screen (sometimes a cloth is also used) is then stretched over a wooden rectangular frame to form what is called a "mold." Another frame, called a "deckle," is placed on top of the mold. The deckle is designed to prevent collected pulp from running off the sides of the mold.

The mold and deckle are then dipped into the fiber-rich water. As they are pulled through the water-and-pulp mixture, a thin, even layer of intertwined fibers comes to rest on the screen. A wet sheet of paper has

been formed! When dried, the fibers become a sheet of paper, ready for use.

Ts'ai Lun, a servant of the Chinese emperor, is credited with discovering the process of creating the first paper in the year 105 CE. Ts'ai Lun probably made paper in much the same way described above, using fibrous plants such as hemp, bark from trees, old rags, and fish nets as sources of fiber. Surprisingly, the same method of making paper is, for the most part, still used today.

The Chinese closely guarded the secret of papermaking for five hundred years. But in 751 CE, during a siege of the city of Samarkland in Central Asia, Arab soldiers captured Chinese paper-makers, who sold their knowledge in return for their freedom.

From there, the practice of making paper slowly made its way through Persia, Arabia, Egypt, and eventually Spain and Europe. It took a full four hundred years after the attack on Samarkland for papermaking to arrive in Europe.

Buddhist missionaries brought papermaking to Japan in 610 CE. At first, paper was used almost exclusively for religious ceremonies and the copying of religious texts. In 770 CE, the Empress Shotoku commissioned a million printed paper prayers to be placed in miniature wooden shrines or pagodas and distributed among the various temples in Japan. This was the first mass text printing on paper.

In the following centuries, both the quality and the availability of paper improved. In Japan, early paper

was often quite thick and strong and was used for many purposes beyond writing or printing. Paper was made into fans, bags, masks, kites, lanterns, clothing, and partition screens. Paper was also oiled, making it waterproof, and used as protection from the rain in umbrellas, windows, and tarpaulins. The uses of paper appeared limitless.

It is unclear when paper folding became an established art form in Japan. Following the introduction of papermaking in Japan, paper was far too valuable to be used recreationally. Because of the rarity and expense of paper, paper folding was predominantly ceremonial, taking the form of religious symbols and secular wrappers for gifts.

By the seventeenth century, during the Tokugawa period, origami flourished. With the publication of the first origami books, *Senbazuru Orikata [How to Fold One Thousand Cranes]* and *Chushingura Orikata [How to Fold the Samurai Story Chushingura]* in the late eighteenth century, the Japanese began to practice origami recreationally. About fifty years later, in 1845, the *Kan no mado [Window on Midwinter]* was also published. Many of the traditional models in origami are derived from these three sources.

Origami has become part of the cultural heritage of the Japanese people. In the West, however, the art remained largely unrecognized until the mid-twentieth century. In 1959, however, a renowned British-based illusionist, Robert Harbin, developed an interest in the art of origami. Fascinated by the potential of paper folding, he collected traditional designs and created his own original origami models. His subsequent book, *Paper Magic*, introduced the word "origami" to numerous Western readers.

The connection between magic and origami remains strong in the Western world. With a single piece of paper, the origamist can create almost any shape he or she can imagine. Much like a magician, the paper holds many secrets. But once you have unlocked these secrets, a whole world of creation opens for you to explore.

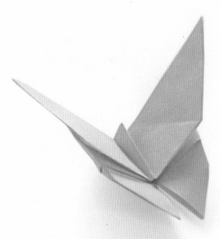

ORIGAMI BASICS

THE RULES OF ORIGAMI

The rules of origami are simple but strict. According to traditional Japanese belief, an origami model should use the paper in the simplest, most efficient way to evoke the spirit of the object being created. To achieve this purity of form, many modern origamists have insisted that origami models be made from a single square sheet of paper. These purists believe that the sheet of paper should only be folded. The paper should never be cut, and even accidental tears are to be avoided. Origamists are strictly forbidden from using another object (like tweezers or rulers) to help make a fold. Glue and tape are also forbidden: the model must hold together on its own. For the most uncompromising of folders, origami's strict rules permit no decoration of the paper. All features, such as eyes and whiskers, must be folded into the paper, not drawn. Ideally, all you need is a square sheet of paper and your hands.

These rules, however, are highly arbitrary. In early, ceremonial origami, the paper was often cut, and multiple sheets of paper were also used. Besides, rules are made to be broken!

Over the years, the rules of origami have evolved and will continue to evolve. By embracing old rules or breaking them, origamists have brought their art to new levels of realism and beauty. Without cutting, the challenge of folding certain objects and animals has produced models of amazing complexity and thickness, so complicated that they almost demand the use of tweezers to help in working with small details. The constraint of not cutting the paper has also contributed to the enormous rise in the application of mathematics to origami.

Origami also need not be limited to a single sheet of paper. Modular origami is the interlocking of multiple origami pieces (units) to form a larger and more detailed structure. The Eight-Pointed Star on page 80 is made from two sheets of paper and is a simple example of modular origami. Using several pieces of paper to make an origami model enables the folder to vary the color of the individual units to create a stunning rainbow effect or to coordinate the colors to achieve realism.

Conversely, a folder can carefully choose a single sheet of paper from which he is able to create a similar realistic or colorful effect. He might choose a marbled paper to capture the look of feathers for a bird, or even make his own paper to create a desired color or texture.

Paper origami models are by nature fragile and difficult to display. To overcome this problem, many folders have no qualms about using glue or tape to help their model hold its shape. Still other, newer techniques include wet-folding or back-coating. These techniques give a model a longer shelf life by wetting the sheet of paper with water before folding or coating the paper with a substance that stiffens the model after drying. These contemporary techniques are even beginning to challenge the most sacred rule of origami: folding. With these techniques, a fold is more like a bend in the paper

(as opposed to a straight crease), allowing the origamist to, in effect, sculpt her model from a sheet of paper.

The initial shape of the paper may also vary from the standard square to rectangles, triangles, hexagons, and circles. Many origamists are even straying from paper itself, using foil, cloth, paper money, doilies, cardboard, and many other substances. The possibilities are endless.

Is nothing sacred in the origami community? I hope not. As with any art form, touching, bending, and then breaking the boundaries of the preconceived rules helps the art to evolve, creating new boundaries.

Still, we all must begin somewhere.

Since this book is an introduction to the art of origami, I have tried not to stray too far from the traditional rules. In looking at the models chosen for this book, you will see that they are all made from a square sheet of paper and require no cuts. I have also tried to choose models that efficiently use the paper to evoke the spirit of the object portrayed.

MATH IN ORIGAMI

Origami is a highly mathematical art. When you fold a sheet of paper, you create crease lines. These crease lines and their intersection points are then used as reference points for the next fold. Hidden within all origami designs is a pattern of geometric creases. While most crease patterns follow a simple system, others are more sophisticated. No crease of the paper relies on guesswork. Each is made by folding one specific point to another and is based in geometric and trigonometric principles. Math is therefore a useful tool for the budding origamist. Here are a few basic principles to keep in mind.

Symmetry

One of first things a new folder will notice about origami is the symmetry of the folds. What you do on one half of the model, you often repeat on the other. The square sheet of paper easily lends itself to various symmetrical designs: a square is symmetrical along its horizontal, vertical, and diagonal axes.

Division

The first fold in many origami models requires the origamist to fold the paper in half. If we fold the model in half a second time, the crease lines divide the paper into four equal parts (fourths). If we fold the model in half yet again, the model is divided into eight equal parts (eighths). Likewise, by folding an edge to an adjacent edge, you will divide the angle separating those edges in half (bisecting the angle). If you fold it in half again, the angle will be divided in fourths. You may not be able to name the

mathematical principle behind what you're doing, but intuitively you'll understand it.

A trickier task is dividing an edge of a square into thirds. To do this, you must fold the top left corner of your square so that it touches the center of the bottom edge of the square, as shown in figure 1. (You can easily find this center point by folding your paper in half along the vertical axis and then unfolding the paper. The crease line will be exactly halfway across the bottom edge of the square.) Now, notice where the top edge of your square touches the right edge of the

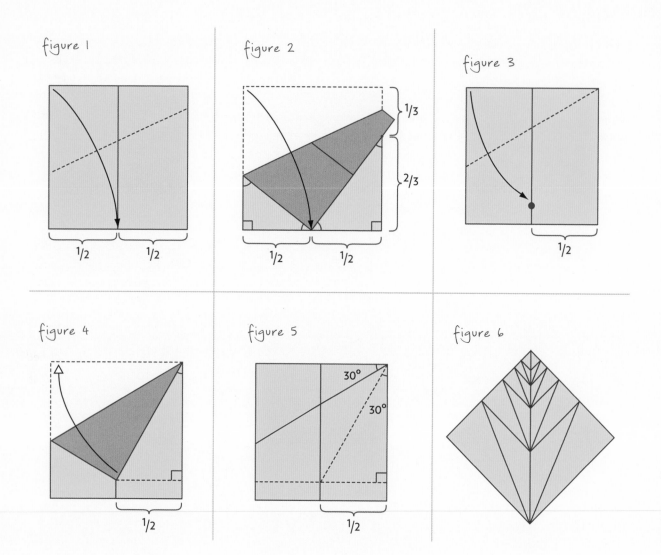

figure 1

1/2 1/2

figure 2

1/3

2/3

1/2 1/2

figure 3

1/2

figure 4

1/2

figure 5

30°

30°

1/2

figure 6

paper (see figure 2). That point is exactly one-third of the way down the edge.

To divide an angle into thirds, you must first fold your square in half along the vertical axis. Then, fold the top left point of your square so that it lies along the center vertical crease line, as shown in figure 3. The crease you make should meet at the top right corner of the square (see figure 4). This crease will trisect the angle of the upper right corner (see figure 5). The Party Hat on page 26 makes use of this technique in folding the top point of the hat.

Self-similar folds

Once you recognize and understand the mathematics governing these origami folds, you can apply what you've learned to create you own origami models. A simple yet fascinating application of mathematics in origami can be found in the Wave. (See page 104 for instructions on how to create this model.) The Wave was jointly discovered by a number of people but was introduced to me by Thomas Hull.

In the Wave, two folds are repeatedly made to the model. As the project progresses, these folds are applied to smaller and smaller portions of the paper. In other words, the two folds are applied recursively; if you had small enough hands and an infinite amount of patience, you could continue folding the paper forever, perpetually dividing the remaining piece of paper. If you unfold the Wave model and look at the pattern of crease lines in the paper, you will see a specific pattern of folds (see figure 6). Notice how each crease bisects the remaining top right and top left edges of the square.

DIAGRAMS

As you fold a model, try to follow the four corners of your original square. Where do they end up in your finished model? Sometimes the corners get tucked away and seem to disappear. At other times, they are a key element (like the head) of the finished model.

Origami diagrams are meant to communicate how to make an origami model. Many creases are added to guide the reader in creating later folds. These extra creases are needed to provide clear instructions for creating the model. Try folding a model without making these extra creases and you'll realize quickly just how important these creases are. To make the folding process easier to comprehend, standard symbols and diagrammatic notations are also necessary. These symbols make the diagram easy to comprehend without additional instructions.

Just as origami diagrams may add extra creases to a model, they may also leave out extra details. These details are left for you to add to the piece. Try experimenting by adding details to a finished model (like a curve in a bird's wing). Doing so adds a distinctive personal touch to your finished piece.

MAKING A SQUARE

All of the origami models presented in this book begin with a square sheet of paper. If you do not have square paper, then follow these simple steps to make a rectangular sheet into a square. An 8½ by 11 inch (21.5 cm x 28 cm) sheet of paper will make a nice square for many of the models in this book.

1) Fold one side of the paper so it lines up with an adjoining side, as shown.

2) Cut off any extra paper and unfold. You should now have a perfect square!

SOME FOLDING HINTS

To make the folding process easier to comprehend, origamists have developed a set of standard symbols for describing how to fold an origami model. Each step in your model will include a picture of the paper as it will appear in front of you, along with symbols for the folds needed to get to the next step. The next step will show what the paper will look like after the required folds have been made.

Here are some things to keep in mind while folding. These hints are not hard-and-fast rules. As folders, each of us needs to discover personally how to best work with a sheet of paper. In my own experience, however, I have found the following tips extremely helpful.

1) Fold on a flat, clean surface. A hard work surface allows you the control necessary to make creases with precision. Cleanliness is also a must. Dirt from the table or your hands can easily rub off onto the paper, detracting from even the most precisely folded models.

2) Take your time to line up the paper carefully before making a crease. The accuracy of your folds contributes enormously to the quality of the finished piece. Once your sides and corners are lined up, hold the paper in place with a finger on your non-dominant hand.

3) To crease the paper, use a finger from your dominant hand and, starting where you are holding the paper (figure 1), slowly slide it to the edge that is being creased (figure 2). From there, move your finger first to one side and then to the other side (figures 3 and 4), creasing the paper as you go. This method may help reduce the number of wrinkles that appear in the paper and will help guarantee that you get it right the first time.

4) Make sharp creases by running your finger, or the back of your fingernail, along the creased edge. A sharp crease allows the paper to remember the fold much more easily and may make future folds easier to do.

5) The next step will show you what the paper should look like now that you've completed the fold.

6) If you have some difficulty making a fold, don't hesitate to turn the paper so that the fold is easier to do. One of the first steps in mastering origami is discovering how you best work with the paper.

figure 1

figure 2

figure 3

figure 4

GETTING STARTED

SYMBOLS

Symbols are the core of any origami diagram. Over the years, origamists have developed a set of standard symbols used all over the world. If you pick up an origami book written in Japanese, you may not be able to read the words, but you should be able to read and follow the diagrams. Following are some of the most common folds and symbols found in origami. Pay attention! These symbols will be used throughout the book, so you might as well learn them now.

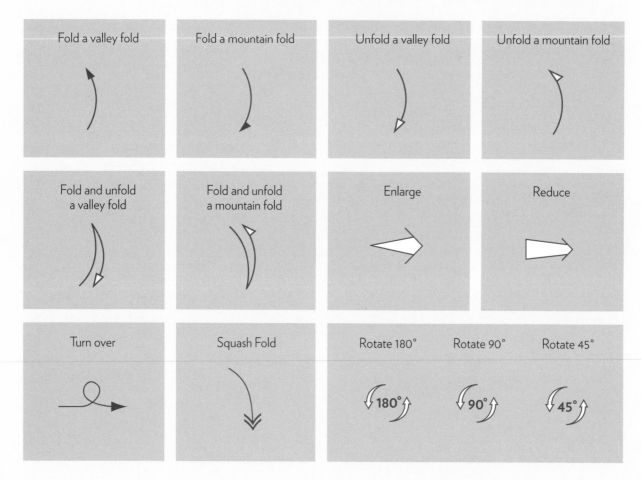

Fold a valley fold

Fold a mountain fold

Unfold a valley fold

Unfold a mountain fold

Fold and unfold a valley fold

Fold and unfold a mountain fold

Enlarge

Reduce

Turn over

Squash Fold

Rotate 180°

Rotate 90°

Rotate 45°

BASIC FOLDS

There are only two basic folds in origami: valley folds (forward folds) and mountain folds (backward folds). These two folds are the cornerstone of all origami models. All other folds are just combinations of the valley and mountain fold.

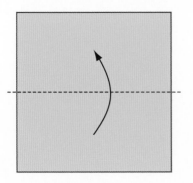

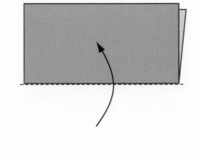

Valley fold

When you make a valley fold, you are creating a valley in the paper. Fold the bottom edge of the square up to the top edge. Align the edges and crease. The valley fold is symbolized by a dashed line and a full arrowhead marking the direction of the fold.

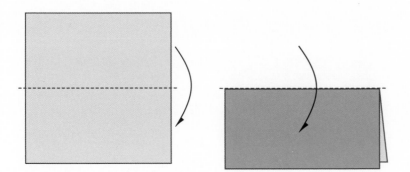

Mountain fold

A mountain fold is a valley fold seen from the other side of the paper. To make a mountain fold, fold the top edge of the paper underneath the square until it meets the bottom edge. Align the edges and crease. Since mountain folds are harder to do than valley folds, it is sometimes easier to turn the paper over, make a valley fold, and then turn back to the front of the paper. A half arrowhead marks the direction of the fold.

Unfold

When a model requires you to unfold a previous fold, an arrow with a white arrowhead is used. Although the fold has been unfolded, the diagram will still show a crease line in the paper.

Fold and unfold (as one step)

A white arrowhead that appears to move forward and then bounce back is used to indicate a single-step fold and unfold. (The crease line and arrowhead indicate whether the fold is a valley or a mountain fold.) The next step shows the new crease line that has been added to the paper.

Unfold a valley fold

Valley fold and unfold

Unfold a mountain fold

Mountain fold and unfold

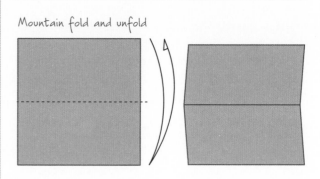

Tuck fold

When the paper needs to be tucked into or behind another sheet of paper, the arrow showing the fold becomes a dotted arrow. Likewise, when a fold continues under a layer of paper, the crease symbol becomes a dotted line.

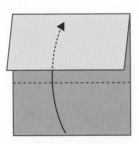 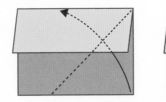 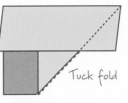

Tuck fold

ADJUSTMENTS TO THE PAPER

Occasionally, the paper you are working with will need to be rotated or turned over. There are special symbols for each of these adjustments. These symbols appear between steps, rather than within them.

Rotating the paper

Rotate the paper in the direction of the arrows. The next step shows what the paper looks like once the rotation is complete. 180-degree rotations and 90-degree rotations are symbolized by an open circle of arrows with the appropriate number of degrees marked in the center.

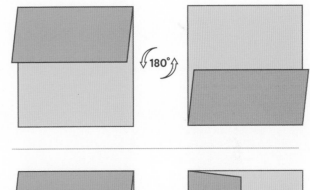

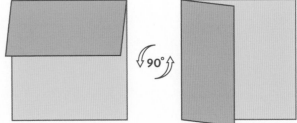

Turning the paper over

Flip the paper over onto the other side as if you were turning the page of a book. The next step shows what the other side of the paper looks like. The symbol for this adjustment is an arrow with a loop in it.

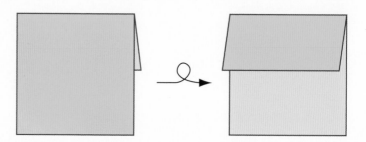

Enlarge a picture

As you fold a piece of paper, the paper becomes smaller and smaller. Likewise, the pictures within each step also get smaller. When the picture gets too small to easily show the next fold, the next step in the diagram is enlarged. The symbol for enlargement is an arrow that is smaller at the tail and larger at the head.

COMBINATION FOLDS

Once you've learned the basic mountain and valley folds, you're ready to attempt more challenging combinations. Specific combination folds form the basis of most origami designs. Mastering the most common combination folds is an important second step for the beginning origamist. While the combinations are limitless, the following folds incorporate many of the techniques used in other variations and combination folds. All combination folds are described in detail as you encounter them in the book.

Squash fold: See page 35.

Outside reverse fold: See page 44.

Rabbit ear fold: See page 52.

Inside reverse fold: See page 55.

Petal fold: See page 83.

COMMON BASES

Along with common folds, there is a set of common bases that serve as starting points for many of the origami models in this book. A base is a sequence of folds at the beginning of an origami model that is the same for multiple origami figures. You will discover these bases as you progress through the models in this book. Once you have encountered the model introducing a specific base, you will be asked to refer back to that model in all subsequent models using that base.

Windmill base

The windmill base is introduced in the Windmill model on page 38.

Kite base

The kite base gets its name from its obvious kite shape. It is the simplest of bases and is introduced in the Swan model on page 42.

Fish base

The fish base is made from two rabbit ear folds. It is an excellent base from which to begin fish models because there are two endpoints for the head and tail of the fish as well as two fins (best exemplified by the Carp model on page 53). The fish base is introduced in the Talking Fish model on page 50.

Blintz base

The blintz base is complete when all four corners of a model are brought into the center and creased. It gets its name from the thin pancake of the same name filled with cottage cheese and wrapped shut by bringing its corners together. The blintz base is introduced in the Fancy Box model on page 57.

Waterbomb base

Named after the traditional Waterbomb, this base provides an excellent starting point for many models because of the four points it produces in the paper. The waterbomb base is introduced in the Waterbomb model on page 64.

Preliminary base

The preliminary base uses the same crease lines as the waterbomb base, but in reverse. Instead of folding the center edges together, it brings the corner points together. The preliminary base is introduced in the Sailboat model on page 73.

Bird base

The bird base is a perfect starting point for bird models because of the five flaps it creates in the paper: two for the bird's wings, one for its head, one for its tail, and one for its body (see the Flapping Bird on page 88 and the Peace Crane on page 92). The bird base is introduced in the Four-Pointed Star model on page 86.

PAPER CHOICES

Most art stores and toy stores carry packs of square origami paper; origami paper can also be purchased online. Origami paper is very thin and is colored on one side only. It comes in different sizes and various colors and patterns. The most common sizes are six inches (15 cm) square and ten inches (25.5 cm) square. If you are a beginner folder, I recommend using ten-inch (25.5-cm) squares.

Foil paper, which has foil on one side (usually colored) and white paper on the other side is another type of origami paper found in stores and online. It is shiny, colorful, and very attractive.

Origami paper varies in price, depending on where and what kind you buy. A pack of one hundred sheets of six-inch (15-cm) paper usually costs between $5 and $8; the same pack of ten-inch (25.5-cm) paper costs between $12 and $15. Paper can also be ordered from the national origami association, Origami USA, in New York City. To get information about the organization, as well as a list of origami books and paper available for purchase, visit www.origami-usa.org.

While some people prefer using origami paper, you don't have to use special paper to complete the models in this book. Origami paper is the most popular but by no means the only choice. You can use almost any square piece of paper for origami, even newsprint and wrapping paper. Try to pick a paper that is strong (but not too thick) and won't fade.

Experiment with different types of paper. Notice how different papers hold a crease. How does the crease unfold or reverse direction? Foil paper will hold a crease quite well, but it is extremely difficult to unfold or even reverse a crease in foil paper. How easy is it to see the crease lines you make in the paper? What effect does the paper have on a finished model? Details are harder to add when you are using a thicker paper, but the finished model is bulkier and sturdier (an effect you may want). The choice of paper is an integral part of the final model and should not be overlooked. The texture and color can have a dramatic effect on your finished model. It may also dictate how the model will be folded.

TRADITIONAL MODELS

WITH PAPER, HELPFUL HINTS, AND THE BASICS OF READING AN ORIGAMI DIAGRAM IN HAND, YOU ARE NOW READY TO BEGIN FOLDING. ORIGAMI APPEALS TO EACH PERSON IN DIFFERENT WAYS. WHETHER YOU'RE INSPIRED BY THE MATHEMATICS OF A MODEL, THE ARTISTRY OF CREATING A BEAUTIFUL OR PRECISELY FOLDED PIECE, OR THE PURE JOY OF FOLDING ITSELF, I HOPE YOU FIND PAPER FOLDING STIMULATING, REWARDING, AND RELAXING. REMEMBER THAT AS LONG AS YOU PRACTICE, YOU WILL IMPROVE. CONCENTRATE ON EACH INDIVIDUAL FOLD AND DON'T WORRY ABOUT THOSE FOLDS YOU'VE ALREADY MADE OR HAVE YET TO MAKE. TACKLE EACH FOLD AS YOU GET TO IT. AND IF AT FIRST YOU DON'T SUCCEED, DON'T DESPAIR. PICK UP ANOTHER PIECE OF PAPER AND TRY AGAIN. THE MORE TIMES YOU FOLD A MODEL, THE MORE PROFICIENT A FOLDER YOU'LL BECOME.

Please note that the numbers in the figures correspond to the step numbers in the text.

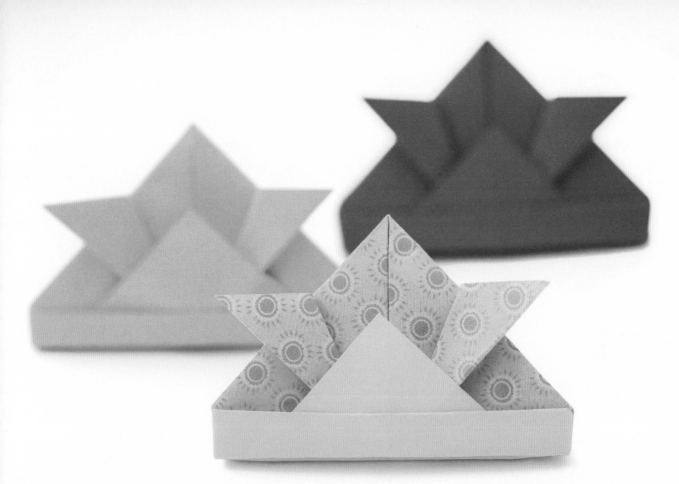

the helmet

The Helmet is a delightful origami model that uses simple valley folds. It provides an excellent introduction to reading origami diagrams. This traditional hat is modeled after the helmets worn by samurai warriors in ancient Japan. If you would like to make a helmet that's large enough to wear, cut a large square from a sheet of newspaper or colorful wrapping paper.

1) Begin with the colored side of the paper facing down and a corner pointing toward you. Valley fold the bottom corner to the top corner and crease. The paper should now form a triangle.

2) Valley fold the left point of the triangle to the top point and crease.

3) Valley fold the right point to the top point and crease. The paper will now resemble a diamond.

4) Valley fold both the top left and right flaps straight down so they touch the bottom of the diamond. Crease.

5) Now valley fold both the flaps out and crease.

6) Rotate the model 180 degrees.

7) Valley fold a single layer of paper from the bottom point up. Crease. Don't let it go all the way to the top point of the hat.

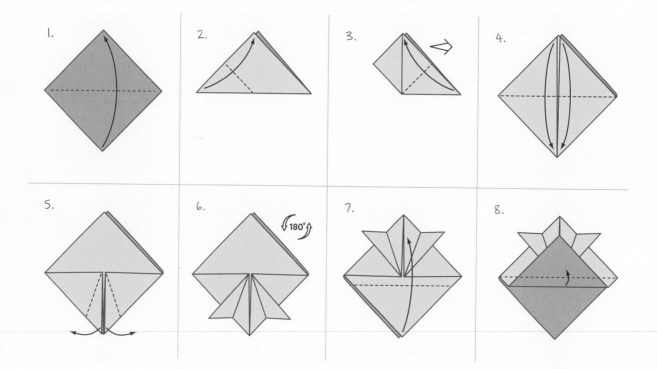

8) Valley fold the remaining flap up and crease to form the rim of the hat.

9) Turn over.

10) Valley fold the side corners in and crease. The farther in you go, the smaller the hat size.

11) Valley fold the bottom point up. Crease. This fold should mirror the fold you made in step 7.

12) Valley fold the remaining flap up and crease to form the rim of the hat.

13) Turn over.

14) Open the bottom of your hat and place it on your head.

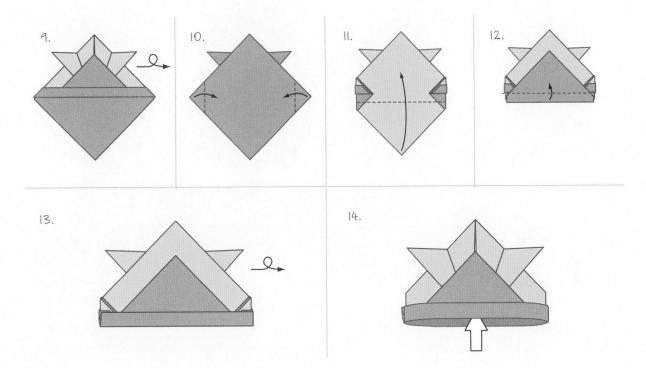

the party hat

The Party Hat is another wearable origami design. It is perfect for children's birthday parties or as a "witch hat" for Halloween. The Party Hat is a classic example of applied mathematics in origami design. The tip of the hat is formed by trisecting a corner of the starting square (steps 1–5).

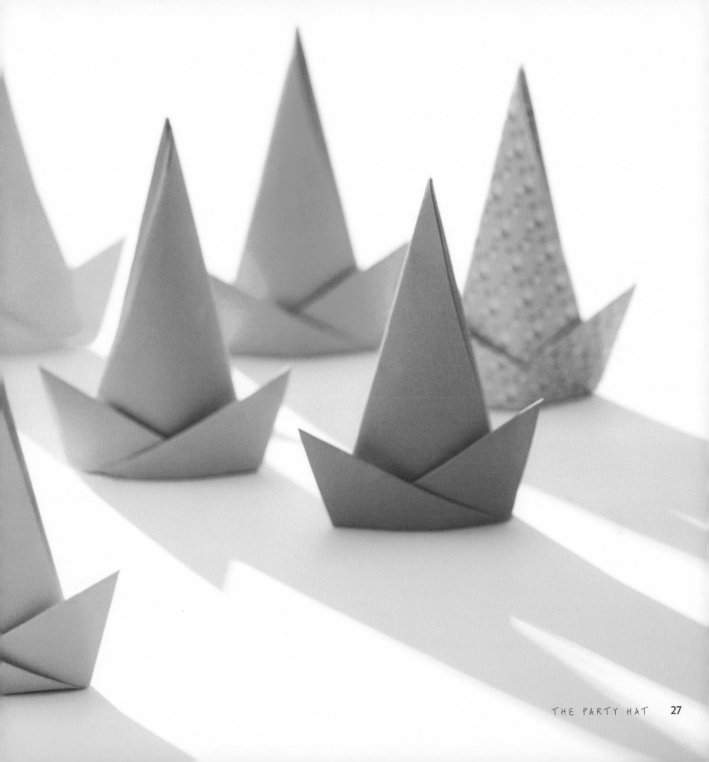

1.

2

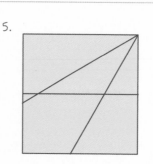

3.

4.

5.

6.

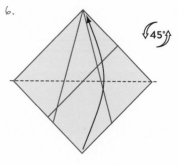

1) Begin with the colored side of the paper facing down and an edge facing you. Valley fold the bottom edge to the top edge. Crease and unfold.

2) Bring the bottom right corner to the horizontal crease line you just made. Move the corner point along the crease line until you can create a crease that will begin at the top right corner. Crease.

3) Valley fold the top edge down so it lies on top of the colored flap.

4) Unfold both flaps.

5) You have just trisected the top right corner of the square. Rotate the model 45 degrees, so that the trisected corner is now pointing away from you.

6) Valley fold the bottom corner to the top corner so the paper forms a triangle. Crease.

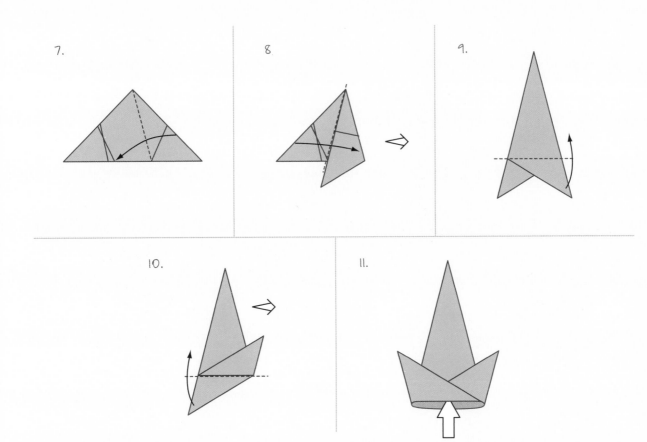

7) Valley fold the right edge of the triangle over and crease. Use the existing crease line on the back of the model to help guide you in making this fold.

8) Valley fold the left edge over and crease. Again, use the existing crease line on the back of the model to help guide you in making this fold.

9) Valley fold the first of the bottom flaps up and crease.

10) Valley fold the second bottom flap up and crease.

11) Open the bottom of your hat and place it on your head.

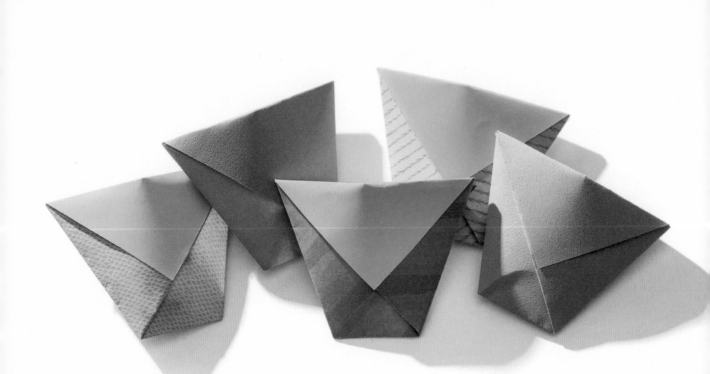

the cup

This is a simple model that can actually hold water. Choose your paper carefully, however: the thinner the paper, the sooner your cup will leak. For a more permanent beverage container, try using waxed paper. Made from a larger sheet of paper and turned upside down, the finished model can also become a conventional hat.

1.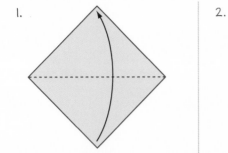

2.

3.

4.

5.

6.

7.

8.

9.

1) Begin with the colored side of the paper facing down and a corner pointing toward you. Valley fold the bottom corner to the top corner and crease.

2) Valley fold a single layer from the right edge of the triangle so it lies against the bottom edge. Crease.

3) Unfold.

4) Valley fold the right point of the triangle over. (It should just touch the point where the crease line reaches the edge of the paper.) Crease.

5) Take a single layer of paper from the top point. Valley fold it down and crease.

6) Turn over.

7) Valley fold the right corner to the opposite corner, as shown, and crease.

8) Valley fold the top point down and crease.

9) Open the top of your cup, pour in water, and have a drink.

the fox puppet

This is a wonderful model that becomes a hand puppet when you are done. Simply place your thumb and index finger in the two pockets and your puppet will open up into a puppet that you can move with your fingers.

In indigenous cultures, the fox's original medicine represents the magic of camouflage, shape-shifting, and invisibility. When folding your paper into the fox, you may choose to meditate on these qualities, and continue to practice bringing your mindful awareness back to your breath, and to the original medicine of the fox. You have the opportunity to contemplate the places in your own life where you may apply the fox's original medicine of camouflage.

NOTE: This model introduces the **squash fold** in step 8.

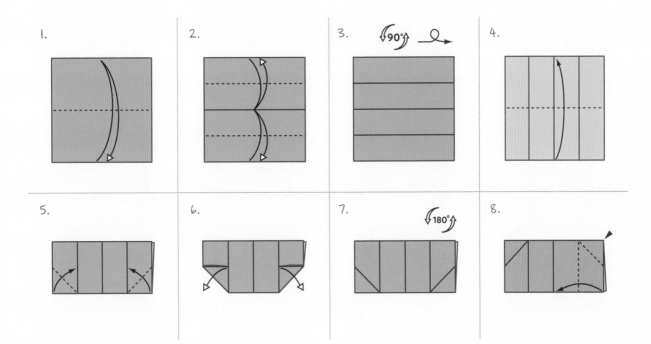

1) Begin with the colored side of the paper facing up and an edge facing toward you. Valley fold the bottom edge to the top edge. Crease and unfold.

2) Valley fold the bottom edge to the center crease line. Crease and unfold.

Then, valley fold the top edge to the center crease line. Crease and unfold.

3) Turn the model over and rotate it 90 degrees so the crease lines now point toward you.

4) Valley fold the bottom edge to the top.

5) Valley fold the bottom right corner so that its bottom edge lies along the first crease mark and crease. Valley fold the bottom left corner in the same way and crease.

6) Unfold the two bottom corners.

7) Rotate the model 180 degrees.

8) Now, squash fold the right side (see page 35).

(continued on page 34)

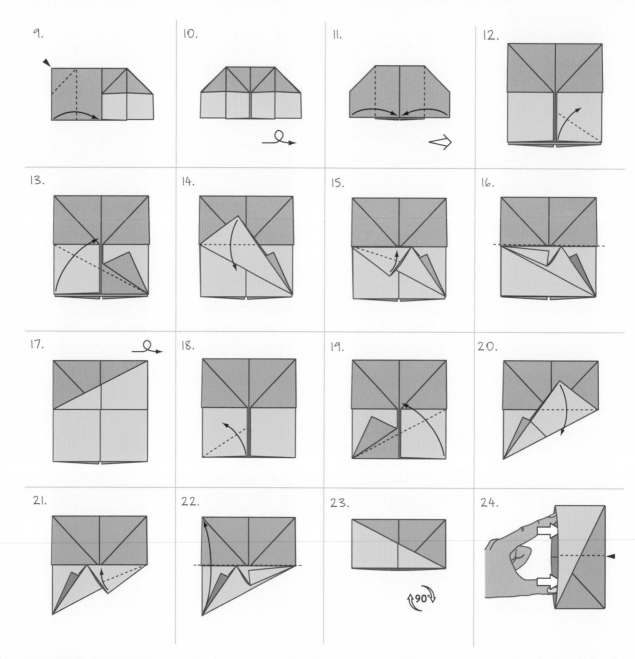

9) Repeat the squash fold on the left half of the model.

10) Turn over.

11) Valley fold both sides to the center crease line and crease.

12) Valley fold a single layer from the left corner of the right bottom square of paper up and crease.

13) Valley fold the entire top layer up and make a crease that begins in the lower right corner and ends in the middle of the left edge.

14) Valley fold the tip of this same flap down and crease.

15) Valley fold up and crease.

16) Valley fold the bottom half up so that it now lies on the top half. Crease.

17) Turn over.

18) Valley fold a single layer from the right corner of the left bottom square of paper up and crease.

19) Valley fold the bottom half up and make a crease that begins in the lower left corner and ends in the middle of the right edge.

20) Valley fold the tip of this same flap down and crease.

21) Valley fold up and crease.

22) Valley fold the bottom half up so that it now lies on the top half and crease.

23) Rotate the model clockwise 90 degrees.

24) Place your index finger and thumb in the back pockets of the puppet. Bring your thumb and pointer finger together as you press lightly on the center of the model from the outside with your other hand.

25) The ears of the fox will lift out from the sides of the puppet as the top and bottom of the mouth come together.

25.

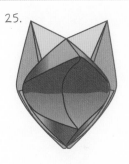

SQUASH FOLD

1) Lift the flap that is to be squashed so that it is pointing straight up in the air.

2) Open each side of the flap. You can stick your finger into the flap to help open it. Notice the black arrowhead at the top of the diagram. This indicates that the point should come straight down as the side flaps open.

3) Keep squashing until the flap lies flat.

4) This is the finished fold.

I.

2.

3.

4.

the windmill

The origin of windmills is obscure, but history indicates that they were used in Persia as early as the tenth century CE. The Persian design was transmitted to China by the beginning of the thirteenth century, where the design was then copied by the Japanese. If you attach your finished model to a stick with a thumbtack or a straight pin, your Windmill will whirl in the wind.

"Air in motion is a force. It is the wind. This wind and the ability to fly and soar upon it reside within the mind," says Ted Andrews in *Animal Speak: The Spiritual & Magical Powers of Creatures Great and Small*. We are reminded of how we can soar on the wind in our minds with our creativity and intuition. As you practice folding your windmill, continue to bring your attention back to the power of the wind and harness your creativity and intuition to imagine soaring on its currents.

NOTE: This model introduces the **windmill base**.

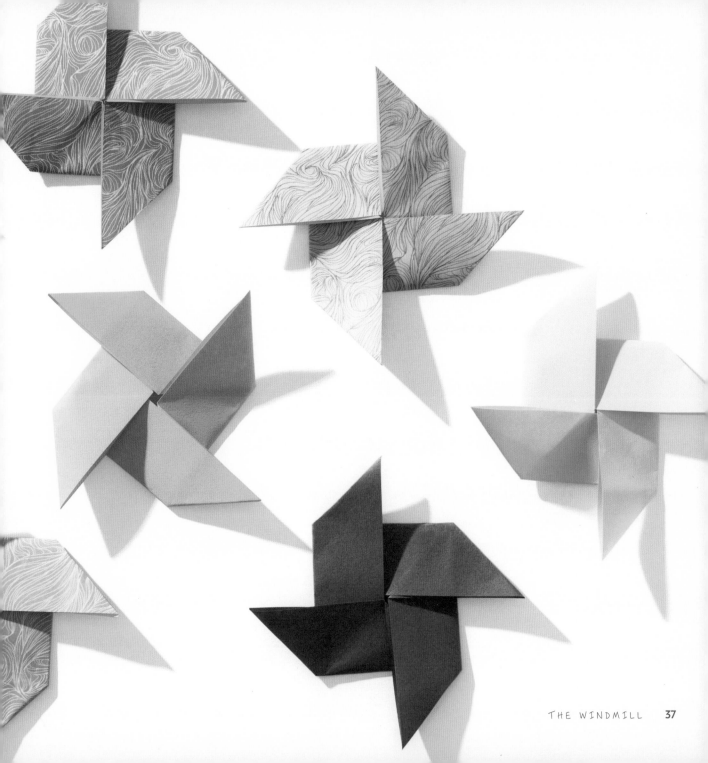

Build the
WINDMILL BASE

1) Begin with the colored side of the paper facing up and a corner pointing toward you. Valley fold the bottom corner to the top corner. Crease and unfold.

2) Rotate the paper 90 degrees.

3) Valley fold the bottom corner to the top corner. Crease and unfold.

4) Blintz the paper by valley folding all four corners to the center and crease.

5) Unfold.

6) Turn over and rotate the paper so that an edge is now facing you.

7) Valley fold the left and right edges to the center. Use the crease lines in the paper to help line up the edges before creasing.

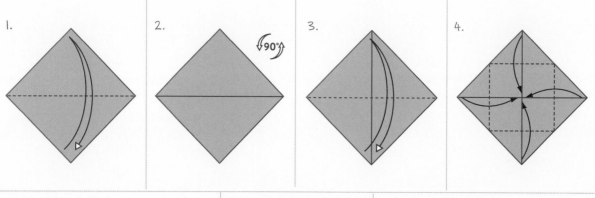

1.

2.

3.

4.

5.

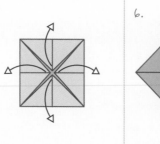

6.

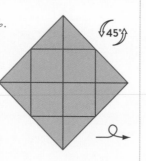

7.

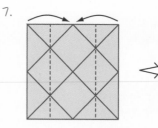

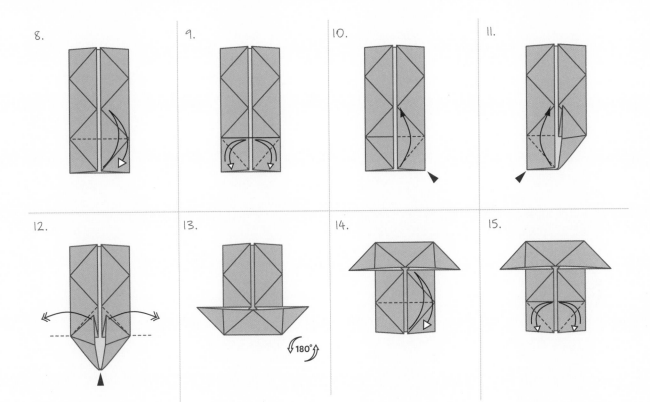

8) Valley fold the bottom edge to the center horizontal. Crease and unfold. Use the crease lines in the paper to help find the center.

9) Valley fold the bottom right corner. The fold is along an existing crease line, and the bottom edge should lie along the center vertical crease. Crease and unfold. Do the same for the bottom left corner.

10) Squash fold the bottom right corner (see page 35).

11) Now, squash fold the bottom left corner.

12) Grabbing the two flaps with the thumb and pointer finger of each hand, gently pull outward until they point straight out to each side. At the same time, the bottom point will begin to lift up and lie flat.

13) Rotate the model 180 degrees.

14) Valley fold the bottom edge to the center horizontal. Crease and unfold.

15) Valley fold the bottom left and right edges to the center vertical. Follow the existing crease lines. Crease and unfold.

(continued on page 40)

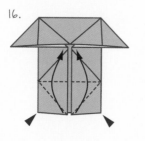

16.

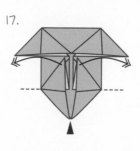

17.

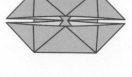

18.

16) Squash fold the left and right corners. Use the existing crease lines to guide the fold.

17) Grab the two flaps with the thumb and pointer finger of each hand and gently pull outward until they point straight out. At the same time, the bottom point will valley fold up and lie flat.

18) This is the windmill base.

Complete the Model

1) Valley fold the top right flap along the existing crease line so that it points straight up and valley fold the bottom left flap along the existing crease line so that it points straight down.

2) Your windmill is now ready to whirl in the wind!

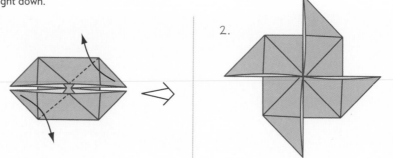

1.

2.

the swan

The swan has long been associated with everlasting love.
As you practice folding paper into the swan, you may meditate on
the sources of love in your life as you fold. Pay attention to and cultivate the seeds
of love. You may feel gratitude for their blossoming. A practice in mindfulness continually
brings our attention back to the present moment. As soon as you are aware that your
thoughts may have drifted, gently bring your attention back to the present moment,
your breath, and your meditation on the sources of mindful love in your life.

NOTE: This model introduces the **kite base** and the **outside reverse fold**.

Build the
KITE BASE

1) Begin with the colored side of the paper facing down and a corner pointing toward you. Valley fold the bottom corner to the top corner. Crease and unfold.

2) Rotate the model 90 degrees so that the crease line is now pointing toward you.

3) Valley fold the two bottom side edges so that they lie along the center crease line of the model. Crease.

4) This is the kite base. Notice the kite shape.

I.

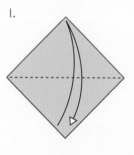

2.

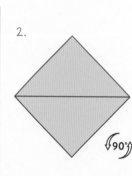

⟲90°⟳

3.

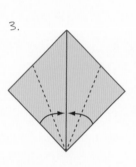

4.

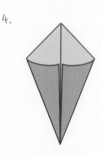

Complete the Model

1) Turn the base over.

2) Valley fold the two bottom side edges so that they lie along the center crease line and crease.

3) Turn over.

4) Valley fold the right side over the left, as shown, and crease.

5) Rotate the model 90 degrees.

6) Valley fold the right point up and crease. This will become the swan's neck. Let the neck tilt back over the swan's back a little.

7) Unfold.

8) Make an outside reverse fold along the crease lines. Open up the bottom of the model to help make this fold. (See page 44.)

9) To make the head of your swan, valley fold the top point of the neck forward and crease.

10) Unfold.

11) Outside reverse fold along the existing crease lines.

12) This is the finished model.

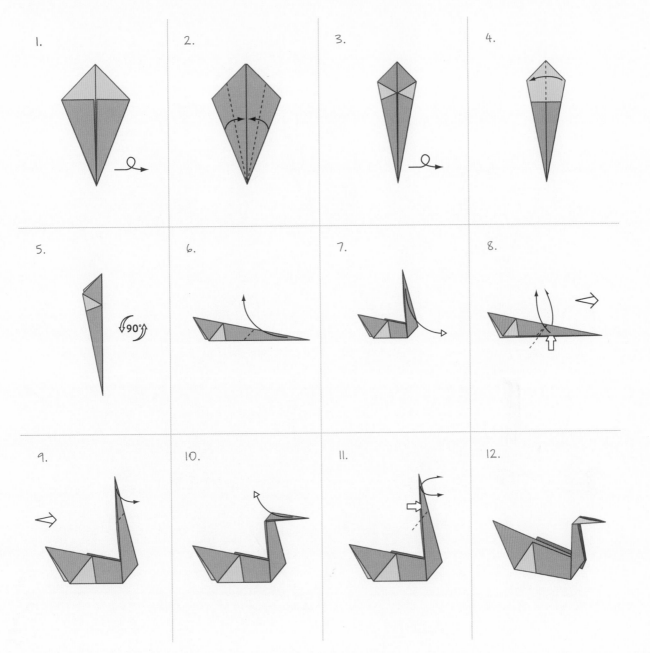

OUTSIDE REVERSE FOLD

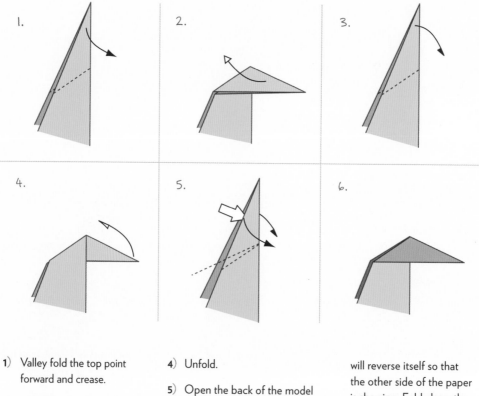

1. Valley fold the top point forward and crease.

2. Unfold.

3. Now mountain fold the top point along the same crease line you made in step 1.

4. Unfold.

5. Open the back of the model and wrap both sides of the top point around each side to the front. (Notice the arrow entering the back of the model.) The top point will reverse itself so that the other side of the paper is showing. Fold along the existing crease lines.

6. This is the finished fold.

the penguin

The Penguin is a fairly simple origami model with widespread appeal. While most penguins have a white breast and a black head and back, many species exhibit red, orange, or yellow patches on the head and neck. Try using a black sheet of origami paper lined with one of these colors. Or choose a textured origami paper for this model. Remember, penguins come in all shapes and sizes, from the giant king penguin to the tiny blue penguin. Try making a whole family of penguins from different sizes of origami paper.

In indigenous cultures, the original medicine of the penguin can represent lucid dreaming. While practicing folding the origami Penguin, you may use your mindfulness practice to induce a lucid dreamlike state as you gently refocus your attention back to your breath and to the present moment without judgment.

1) Begin with the colored side of the paper facing up and a corner pointing toward you. Valley fold the bottom corner to the top corner and crease.

2) Valley fold the left point of the triangle to the top point and crease.

3) Unfold.

4) Valley fold the top point (one layer) of your triangle down to the crease line you just made in the paper. The crease you make should come to a point at the bottom right point of the triangle.

5) Turn over.

6) Valley fold the top point of the triangle down to the crease mark. This should look just like the flap on the other side.

7) Unfold.

8) Rotate the model clockwise 90 degrees.

9) Valley fold the bottom point up to where the crease lines meet.

10) Valley fold the model in half.

11) To make the penguin's head, valley fold the top point forward. Crease.

12) Unfold.

13) Make an outside reverse fold along the existing crease lines. (See instructions for making an outside reverse fold, page 44.)

14) This is the finished model.

I.
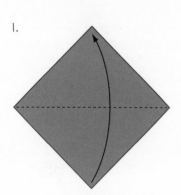

2.
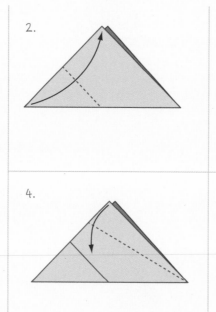

3.
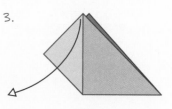

4.

5.

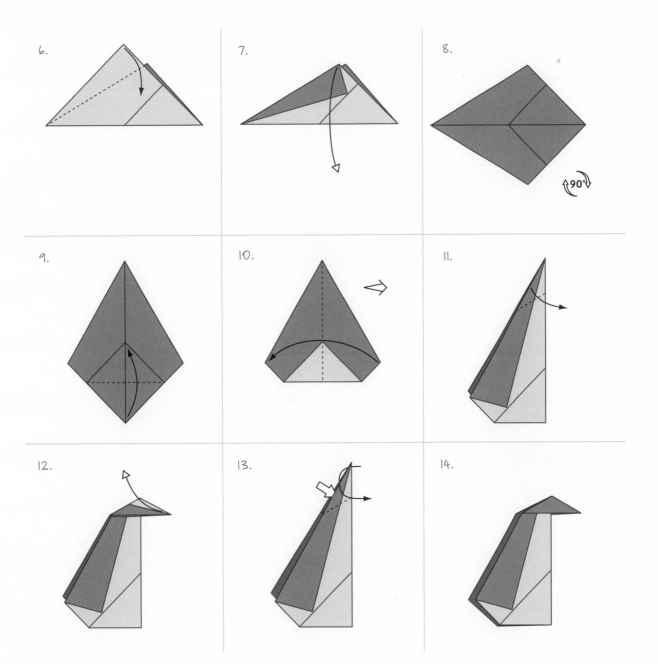

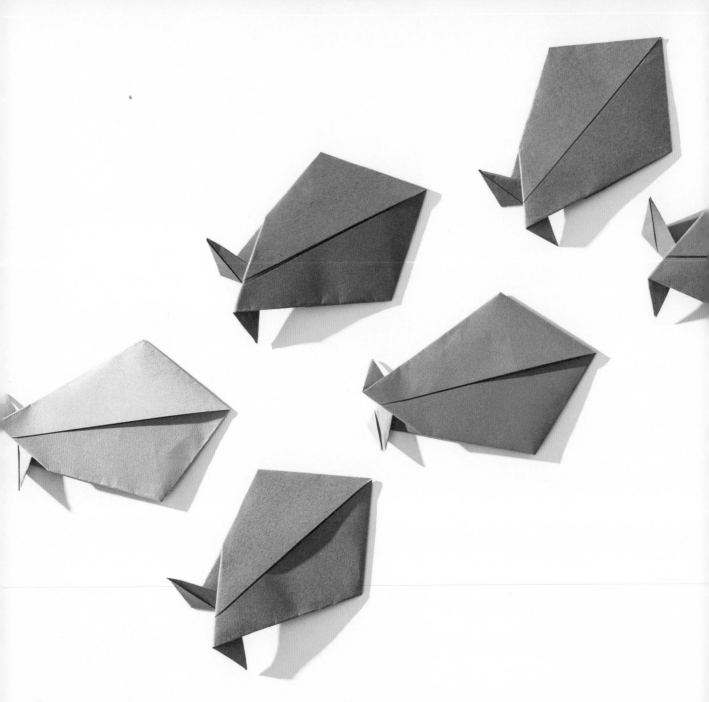

the talking fish

The Talking Fish, much like the Fox Puppet, is an action model. Action models are meant to be played with. If you move the tail fins of your Talking Fish up and down, its jaws will move back and forth and it will appear to talk.

As Ted Andrews writes in *Animal Speak: The Spiritual & Magical Powers of Creatures Great and Small*, "Various fish and other forms of aquatic life symbolize guidance to specific expressions of intuition and creative imagination." As you practice mindfulness while folding the Talking Fish, you may bring your attention to, and meditate upon, the role that intuition and creative imagination play in your life.

NOTE: This model introduces the **rabbit ear fold** and the **fish base.**

Build the
FISH BASE

1) Begin with the colored side of the paper facing down and a corner pointing toward you. Fold the bottom corner to the top corner. Crease and unfold.

2) Rotate the model 90 degrees.

3) Valley fold the bottom corner to the top corner.

Crease and unfold.

4) Valley fold the top right edge of the paper so that it lies along the center crease line and unfold. Crease only to the horizontal crease line.

5) Valley fold the bottom right edge of the paper so that it lies along the center crease

line and unfold. Again, crease only to the horizontal crease line.

6) Make a rabbit ear fold on the right side of the paper. (See page 52.)

7) Valley fold the top left edge of the paper so that it lies along the center crease line and unfold.

8) Valley fold the bottom left edge of the paper so that it lies along the center crease line and unfold.

9) Using the existing crease lines, make a rabbit ear fold in the left side of the paper.

10) This is the fish base.

1.

2.

3.

4.

5.
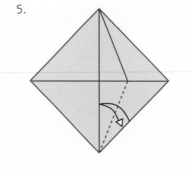

6.
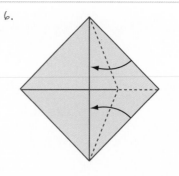

7.

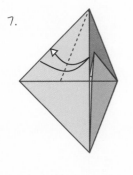

8.

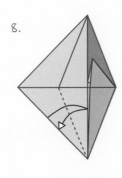

9.

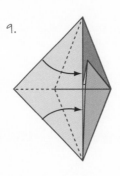

10.

Complete the Model

1.

2.

90°

1) Turn the base over.

2) Rotate the base 90 degrees.

3) The two ends will become the fish's tail fins. Valley fold the left corner so it points down and crease. Valley fold the right corner so it points up and crease.

4) Valley fold the left side over to the right and crease. If you hold the fish by its tail fins and slide them up and down against one another, the fish's mouth moves from side to side.

5) This is the finished model.

3.

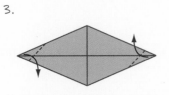

4.

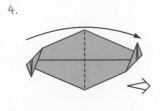

5.

RABBIT EAR FOLD

1) Valley fold the top edge to the center vertical crease line. Crease only to the horizontal crease line.

2) Unfold.

3) Valley fold the bottom edge to the center vertical crease line. Again, only crease up to the horizontal crease line.

4) Unfold.

5) Now valley fold along the two creases you just made.

6) As you valley fold the paper, a little ear will begin to form. Keep folding until the ear sticks straight up.

7) Fold the ear to one side so that it lies along the center vertical.

8) This is the finished model.

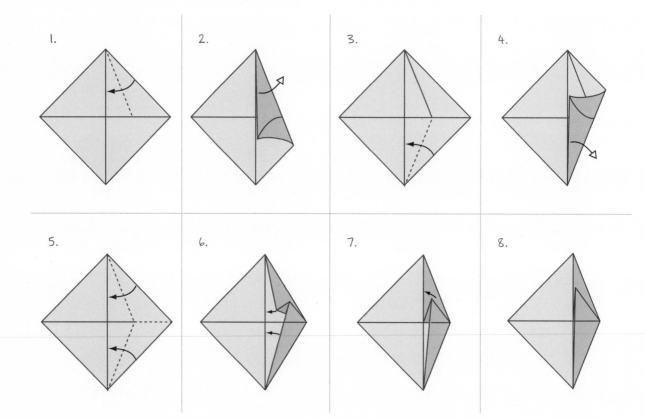

1.

2.

3.

4.

5.

6.

7.

8.

the carp

The coastal waters and rivers of Japan teem with fish, which are caught in enormous quantities for use as both fresh food and fertilizer. The carp holds a special significance for the Japanese: during the late spring, it swims upstream to mate. To the Japanese, the carp is a symbol of courage, perseverance, and vigor.

You may use your mindfulness practice while folding the carp to remind yourself of its qualities. Macrobiotic ideas about food say that we will embody the energy of the food we eat—for example, wild salmon also brave the river's currents, and when you eat salmon, macrobiotic food principles state that you will gain the salmon's courage, perseverance, and vigor. By reflecting on these qualities in a mindful way as you fold the Carp, you also create a space to invite these qualities into your life.

NOTE: This model introduces the **inside reverse fold**.

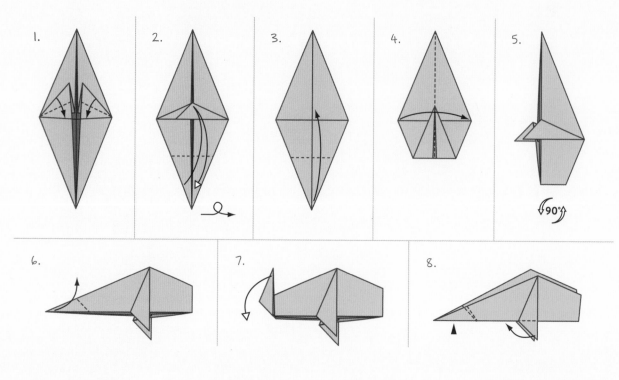

1) Begin with a fish base. (See the Talking Fish, page 49.) Valley fold the diagonal edges of the center flaps down so that they lie on the horizontal crease line. Crease. These flaps will become the fins of the Carp.

2) Valley fold the bottom point up so that it touches the top of the fins. Crease and unfold. Turn over.

3) Using the crease line made in step 2, valley fold the bottom point up.

4) Valley fold the left side over to the right and crease.

5) Rotate the model 90 degrees.

6) Valley fold the point of the tail up and crease.

7) Unfold.

8) Inside reverse fold the tail along the existing crease lines. (See page 55.)

9) Valley fold the bottom point of the carp's fins out to each side.

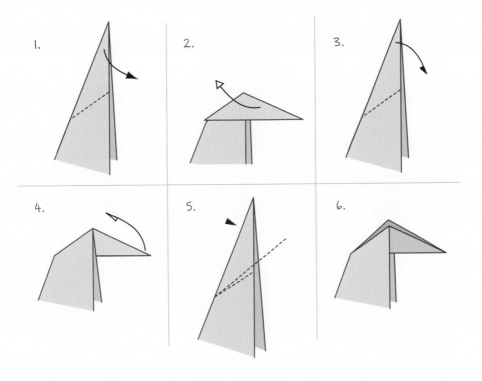

INSIDE REVERSE FOLD

1) Valley fold the top point forward and crease.

2) Unfold.

3) Now mountain fold the top point along the same crease line you made in step 1.

4) Unfold.

5) Open the front of the model and push the back of the top point (notice the black arrowhead) toward the front. The top point will reverse itself so that the other side of the paper is showing. Fold along the existing crease lines.

6) This is the finished fold.

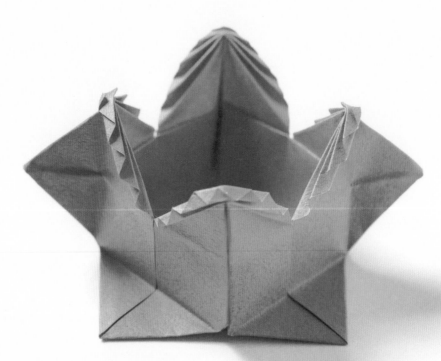

the fancy box

This is the first of two boxes diagrammed in this book. An interesting feature of this box is the ruffled edge (or pleat) that appears in each of the four corners. When folding the Fancy Box, be sure to line up the folds as best you can. The folding steps are not difficult to master. The sole challenge comes in making the folds as accurate as possible. The Fancy Box introduces the pleat fold and the blintz base. The pleat fold resembles the back and forth folds used to make a paper fan.

NOTE: This model introduces the **blintz base**.

1.

2.

3.

4.

5.

Build the
BLINTZ BASE

1) Begin with the colored side of the paper facing down and a corner pointing toward you. Valley fold the bottom corner to the top. Crease and unfold.

2) Rotate the model 90 degrees.

3) Again, valley fold the bottom corner to the top corner. Crease and unfold.

4) Valley fold all four corners to the center. Make sure the corners meet in the center. Crease.

5) This is the blintz base.

1.

2.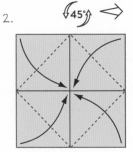

3.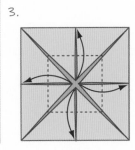

4.

Complete the Model

1) Turn the base over.

2) Blintz the paper again by valley folding all four corners to the center and creasing. Now, rotate the model 45 degrees.

3) Valley fold the four points in the center back out to the edges and crease.

4) Turn over.

(continued on page 58)

5.

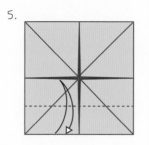

6.

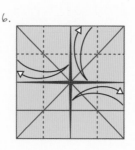

7.

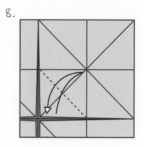

8.

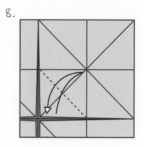

5) Valley fold the bottom edge to the center. Crease and unfold.

6) Now do the same for the remaining three sides by valley folding them to the center, creasing, and unfolding the paper.

7) Choose a corner to work on. Valley fold a single layer from the center point up to its outer corner. Crease and unfold.

8) Valley fold the same point up to the center crease line you just made. Crease and unfold.

9) Valley fold the point up again to the crease line you made in step 8 and crease.

10) Valley fold along the existing crease line you made in step 8.

11) Valley fold the bottom edge to the center crease line.

12) Unfold.

13) Valley fold the point up to the outer corner along the existing crease line.

14) Now valley fold the top point down to the first crease line.

15) Mountain fold along the existing crease line.

16) Valley fold the top edge to the next crease line.

17) Continue with steps 15 and 16 until you reach the bottom. These repeating backward and forward folds are called pleats.

18) You have now finished pleating this corner of the model.

19) Now make similar pleat folds in the remaining three corners, repeating steps 7 through 17 for each.

20) To open the box, stick a finger under one of the corner flaps and pinch the outer corner edges together. Let the sides of the box come up along the existing crease lines. As you pinch the sides, let the pleat folds fan open to each side; don't pinch the top pleated point.

21) Now open the remaining three corners one at a time. Once that's done, adjust the model by straightening the side edges and folding the four triangular side flaps straight out. (These give the model a wider base to stand on.)

22) This is the finished model.

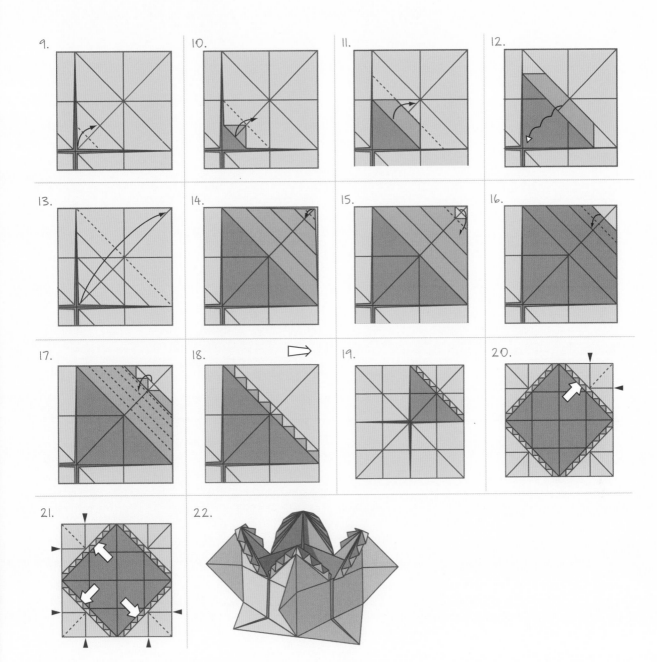

9. 10. 11. 12.

13. 14. 15. 16.

17. 18. 19. 20.

21. 22.

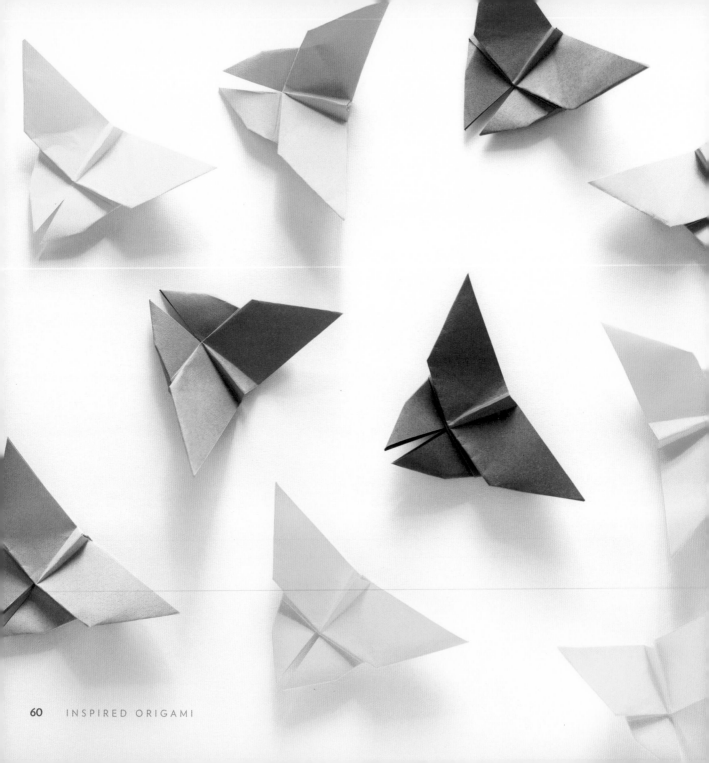

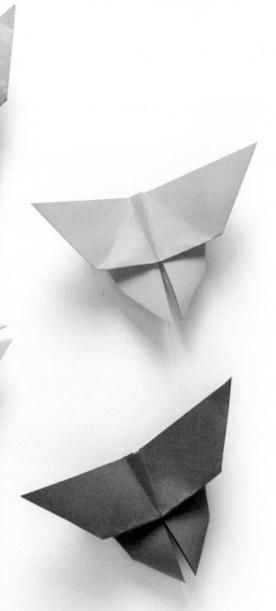

the butterfly

The Butterfly is a simple yet delightful action model whose wings flap when the body of the butterfly is pressed up and down. In Japan, it is traditional to decorate bottles of sake (a Japanese wine) at wedding ceremonies with male and female paper butterflies. Choosing paper with different colors or patterns adds dimension to your finished model, so choose your paper with care!

From the humble caterpillar to the beautiful butterfly, this creature is symbolic of transformation. You may practice mindfulness in meditating on the principle of change as you fold your origami butterfly. As you notice your attention wandering, bring your awareness back to your breath and you may contemplate the transformational energy embodied in a butterfly and how it mirrors the transformation of your origami paper.

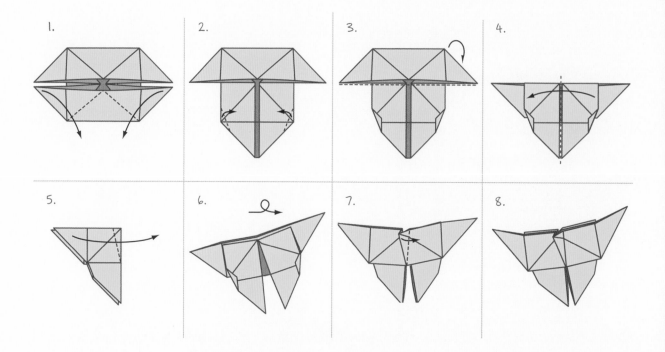

1) Begin with the windmill base (see the Windmill, page 36). Valley fold the bottom left and right flaps along the existing crease lines so that they point straight down.

2) Valley fold the corners of the bottom flaps in.

3) Mountain fold the top back.

4) Valley fold the right wing over on top of the left wing.

5) Take hold of the wing you just folded and valley fold it back to the right. Don't unfold it, but slant the wing up.

6) Turn over.

7) Grab the small flap in the center of the model and valley fold it across. This will form the body of your butterfly.

8) Unfold the small flap so it sticks straight up. Now rest the butterfly on a flat surface and press up and down on the center of its body. The wings will spring up from the sides as if the butterfly were flying.

the waterbomb

The Waterbomb requires a unique last step. After you have completed the final fold, you must blow into the model to create a cube. Beware: this model can hold water and has the potential of living up to its name! You can also draw dots on the sides of your Waterbomb to create a homemade die.

NOTE: This model introduces the **waterbomb base**.

Build the
WATERBOMB BASE

1) Begin with the colored side of the paper facing up and an edge facing you. Valley fold the bottom edge to the top edge. Crease and unfold.

2) Rotate the model 90 degrees.

3) Valley fold the bottom edge to the top. Crease and unfold.

4) Turn over.

5) Valley fold the bottom left corner to the top right corner. Crease and unfold.

6) Likewise, valley fold the bottom right corner to the top left corner. Crease and unfold.

7) Using the existing crease lines, bring the center of the left and right edges together so that they meet

at the center of the bottom edge. The top edge will come down and lie flat on top of it.

8) This is the waterbomb base.

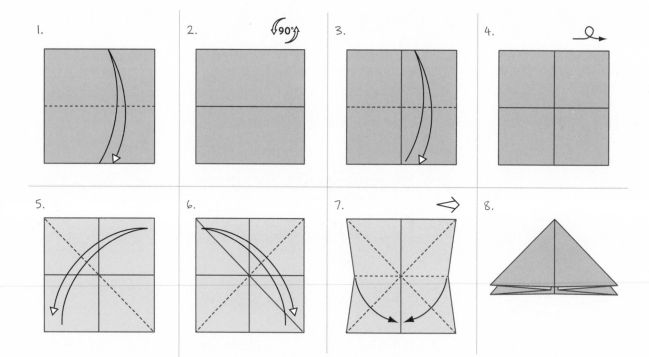

Complete the Model

1) Take a single flap from the right and valley fold its point to the top point of the triangle. Crease.
Do the same with a single left point.

2) Valley fold the right point you just folded, to the right point of the center diamond. Now fold the left point to the left point of the center diamond.

3) Valley fold the same point to the center. Do the same with the other side.

4) Unfold the small triangle on the right and left.

5) Valley fold the right corner of the diamond into the center. Repeat with the left corner.

6) On the top edge of the corner you just folded into the center is a flap that can be opened up. Stick your finger into the flap to help open it. Once it is open, tuck the top triangle into the opened flap and press flat. Do the same with the left side.

(continued on page 66)

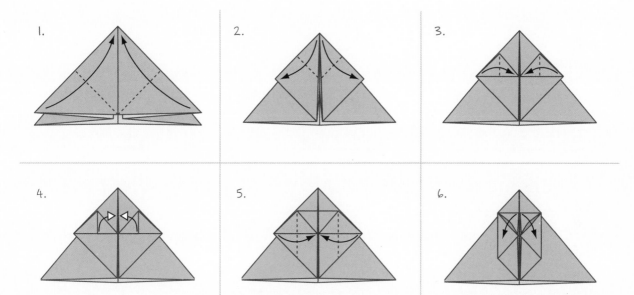

7) Turn over.

8) Repeat steps 1 through 7 on this side.

9) Valley fold the top point to the center. Crease and unfold. Now, valley fold the bottom point to the center. Crease and unfold.

10) Then, fold the existing creases in the opposite direction. Mountain fold both the top and bottom points to the center. Crease and unfold.

11) To inflate the waterbomb, open the sides so that the edges point in different directions. Loosely hold the paper in your hands, being careful not to pinch the side edges. Gently blow into the bottom hole to inflate the waterbomb. Once the waterbomb is inflated, straighten the edges of the cube.

12) This is the finished model.

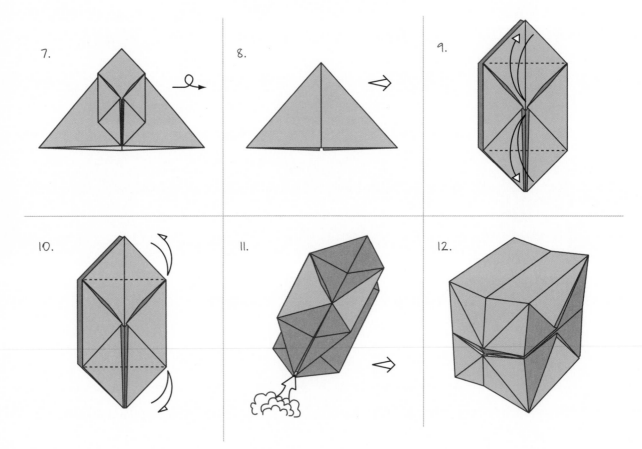

7.

8.

9.

10.

11.

12.

the jumping frog

The Jumping Frog is a versatile action model that can be used in numerous games. Try making the frog jump into a container, or count how many flips you can get it to do in the air. You can also race two frogs or try setting and breaking your own long-distance jumping records. Try making up your own games and contests.

Like butterflies, frogs are symbols of transformation—as shown by the tadpole becoming a frog. As with the butterfly, you may practice mindfulness in meditating on the principle of transformation as you fold your jumping frog.

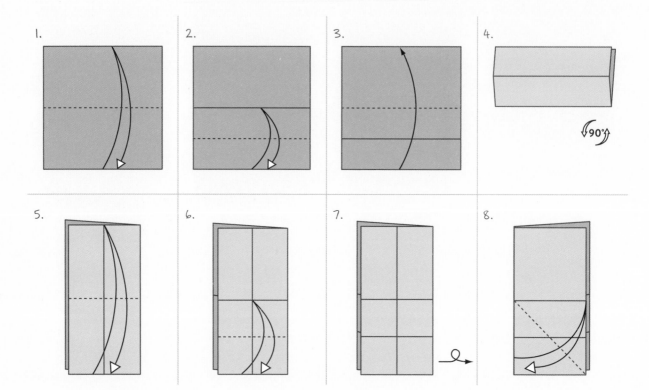

1) Begin with the colored side of the paper facing down and an edge facing you. Valley fold the bottom edge to the top edge. Crease and unfold.

2) Valley fold the bottom edge to the center crease line. Crease and unfold.

3) Refold the bottom edge to the top edge.

4) Rotate the model 90 degrees.

5) Valley fold the bottom edge to the top edge. Crease and unfold.

6) Valley fold the bottom edge to the center crease line. Crease and unfold.

7) Turn over.

8) Valley fold the bottom left corner to where the center crease line touches the right edge. Crease and unfold.

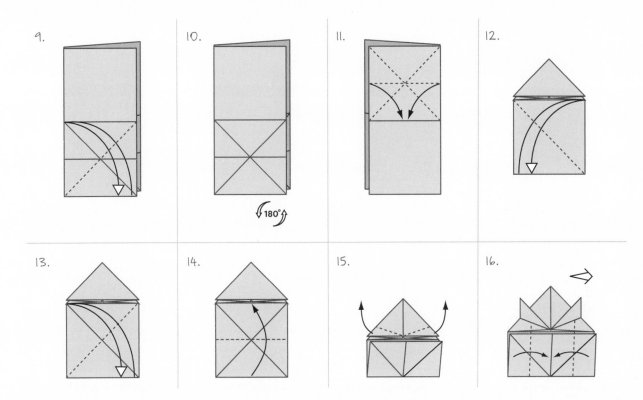

9) Valley fold the bottom right corner to where the center crease line touches the left edge. Crease and unfold.

10) Rotate the model 180 degrees.

11) Using the existing crease lines in the top half of the paper, bring together the center of the left and right edges of the top half of the paper so that they meet at the center of the paper. The top edge will come down and lie on the center horizontal crease line. You are folding a waterbomb base in the top half of the paper.

12) In the bottom square of the paper, valley fold the bottom left corner to the opposite corner. Crease and unfold.

13) Likewise, valley fold the bottom right corner to the opposite corner. Crease and unfold.

14) Valley fold the bottom edge to the base of the top triangle. Crease.

15) Returning to the top triangle, valley fold the right flap of the triangle up to form the frog's front foot. Do the same with the left flap of the triangle.

16) Valley fold both side edges to the center.

(continued on page 70)

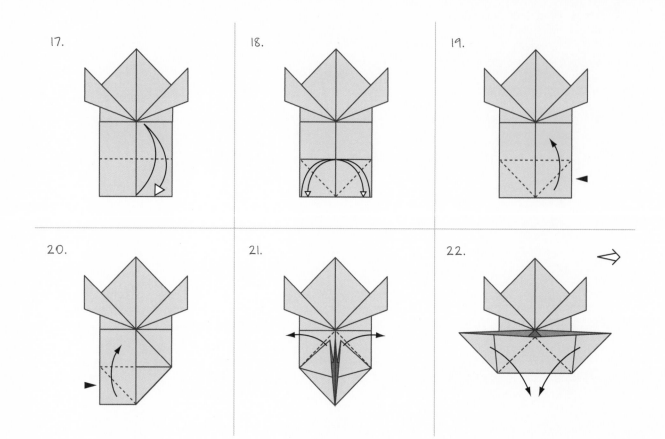

17) Fold the bottom edge up. Crease and unfold. The paper is getting a little thick to work with at this point, but try to keep the paper together and make the creases as best you can.

18) Valley fold the bottom corners in so that the bottom edge lies along the center crease line. Crease and unfold.

19) Squash fold the bottom right corner (see page 35) using the existing crease lines.

20) Squash fold the bottom left corner using the existing crease lines.

21) Grab the flaps with the pointer finger and thumb of both hands and gently pull so these flaps point straight out. The bottom will valley fold up and lie flat.

22) Valley fold the two flaps straight down.

23.

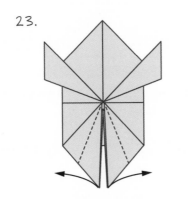

24.

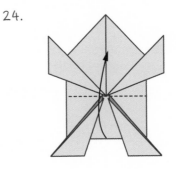

25.

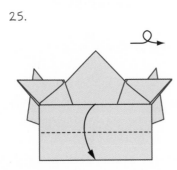

26.

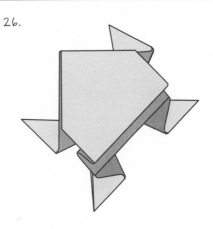

23) To make the back feet of your frog, valley fold the right flap out to the right. Do the same for the left flap.

24) Valley fold the entire frog in half.

25) Valley fold the feet down. Turn over.

26) Now, push down on the hind quarters of the frog and let your finger slide off. Your frog will jump (even flip) through the air.

the sailboat

The traditional sailboat is the symbol of the National Origami
Association, Origami USA. As you practice folding your origami
sailboat, you may continually bring your awareness back to the
similarity between a sailboat and a mindfulness practice. Just as
the keel of a sailboat helps the ship right herself after she leans
over in the wind, so our mindfulness practice brings us back to
center. We can't control the wind, but we can set our sails, harness
the power of the wind, and enjoy the ride. A committed,
joyful, and diligent mindfulness practice
creates the space to cultivate inner
equanimity and resilience.

NOTE: This model introduces
the **preliminary base**.

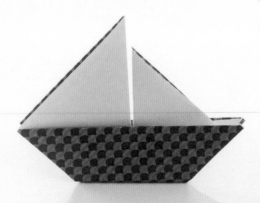

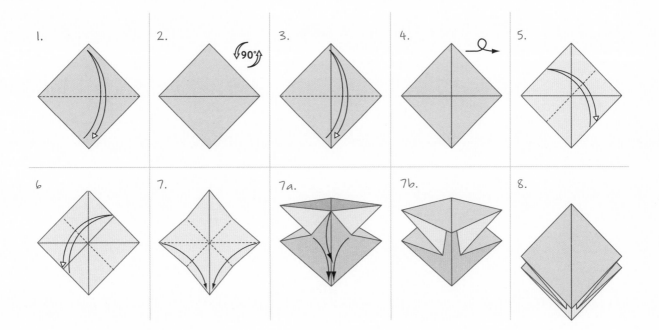

Build the
PRELIMINARY BASE

1) Begin with the colored side of the paper facing up and a corner pointing toward you. (If you begin with the colored side of the paper facing down, the sails of your boat will be colored.) Valley fold the bottom corner to the top corner. Crease and unfold.

2) Rotate the model 90 degrees.

3) Valley fold the bottom corner to the top corner. Crease and unfold.

4) Turn over.

5) Valley fold the bottom right edge to the top left edge. Crease and unfold.

6) Valley fold the bottom left edge to the top right edge. Crease and unfold.

7) Bring the left and right corners of the square together so that they meet at the bottom corner (7a.) The top corner will also come down to the bottom corner (7b.) Press flat.

8) This is the preliminary base.

(continued on page 74)

Complete the Model

1) Rotate the base 180 degrees so that the open end is facing up.

2) Valley fold the top corner (a single layer of paper) down to the bottom corner. Crease and unfold.

3) Take the same single layer of paper and mountain fold it backward into the base of the boat. Fold along the existing crease line. You will need to open the paper up a little to do this.

4) Turn over.

5) Valley fold the top corner (a single layer of paper) down to the bottom corner. Crease and unfold.

6) Mountain fold the paper backward into the base of the boat.

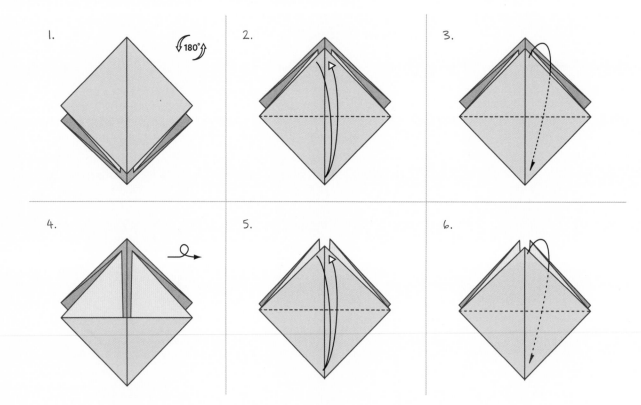

7) To make the boat's back sail slightly smaller than the front one, valley fold the sail straight down.

8) Now valley fold the sail back up, slanting it a little.

9) Tuck the leftover sail into the base of the boat.

10) Valley fold the bottom corner up to the deck of the boat. Crease and unfold partway. Use this triangular flap to help stand the boat up.

11) Turn over.

12) This is the finished model.

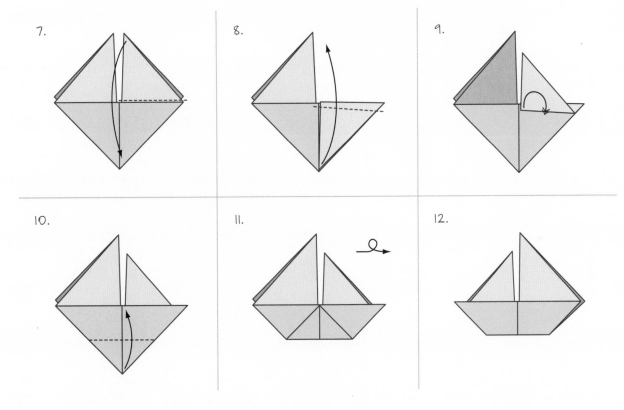

7.

8.

9.

10.

11.

12.

the box with lid

This is the second box diagrammed in this book.
This model is a handy storage box for paper clips, pennies,
rubber bands, and numerous other small items. It's also the
perfect size for favors at holiday parties. This box uses the
preliminary base to provide the bottom and sides of the box.
Extra flaps are used to create a lid.

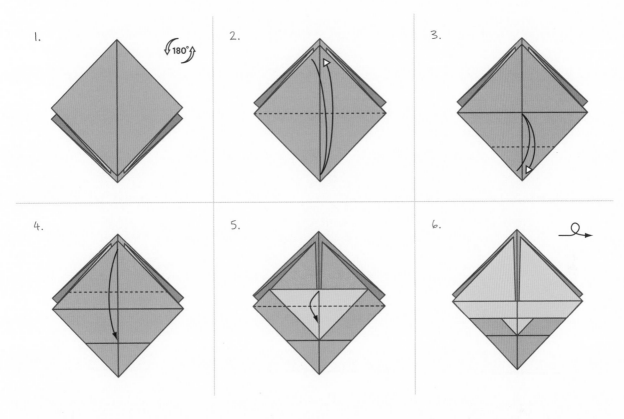

1) Begin with the preliminary base (see the Sailboat, page 73). Rotate the model 180 degrees.

2) Valley fold a single layer of paper from the top corner to the bottom corner. Crease and unfold.

3) Valley fold the bottom corner to the center. Crease and unfold.

4) Valley fold a single layer from the top corner to the crease line you just made. Crease.

5) Now valley fold the remaining flap along the center horizontal.

6) Turn over.

(continued on page 78)

7.

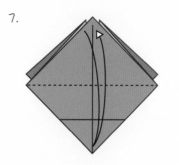

8.

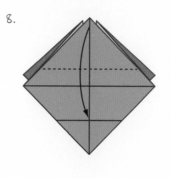

9.

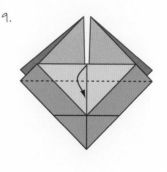

10.

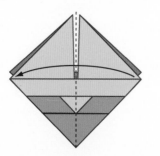

11.

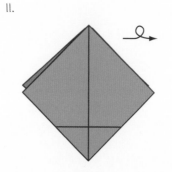

12.

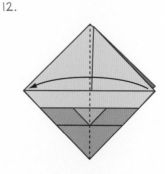

7) Valley fold a single layer of paper from the top corner to the bottom corner. Crease and unfold.

8) Valley fold a single layer from the top corner to the first crease line from the bottom and crease.

9) Now valley fold the remaining flap along the center horizontal.

10) Valley fold a single point from the right corner over to the left corner.

11) Turn over.

12) Again valley fold a single layer from the right corner to the left corner.

13) Valley fold the top corner to the bottom corner. Crease and unfold.

14) Valley fold the left, right, and top points (a single point from each) to the center and crease.

15) Now valley fold the top flap down along the center horizontal.

16) Turn over.

17) Valley fold the top corner to the bottom corner. Crease and unfold.

18) Valley fold the left, right, and top corners to the center and crease.

19) Now valley fold the top flap down along the center horizontal.

20) Open the box by pulling the front and back edges apart. The bottom point will open flat and become the bottom of the box. Straighten the edges of your box.

21) This is the finished model.

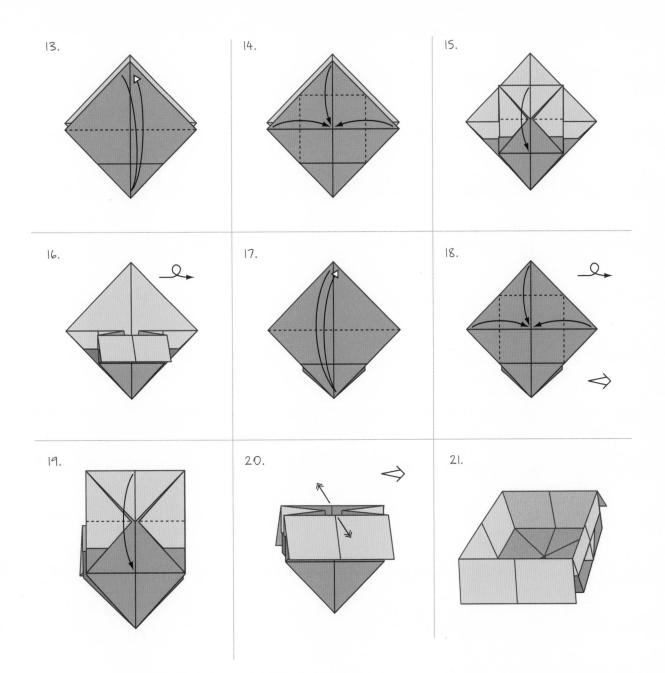

the eight-pointed star

The Eight-Pointed Star provides an excellent introduction to the petal fold. It is also the only modular model in this book, meaning that it requires two sheets of paper. This model makes a perfect Christmas tree decoration. Both sheets must be the same size, but try experimenting with different colors and types of paper.

Through the ages, stars have inspired humans to identify and name constellations. Stars were used in ancient cultures to create astrological natal charts and consider planetary transits. We have songs about twinkling stars and make wishes upon a star. We often place a star atop a Christmas tree. The list goes on and on. Stars offer a little magic to light up a space.

When you practice folding an origami star, you may meditate on the positive qualities stars have brought into your own life. Continue to bring your awareness back to your breath and to your folding practice and to the essence of the star quality in your life.

NOTE: This model introduces the **petal fold**.

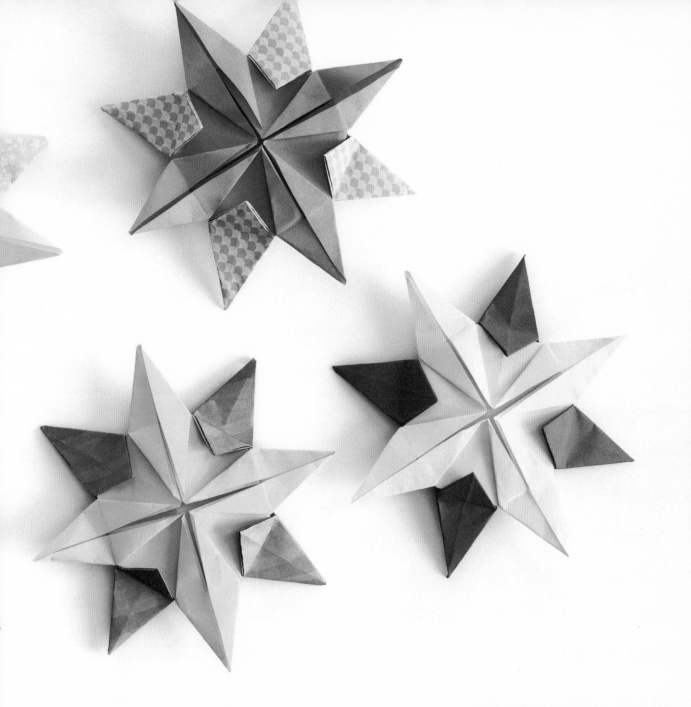

1) Using one sheet of paper, begin with the windmill base (see the Windmill, page 36). Valley fold the top right point into the center. Crease and unfold.

2) Now, squash fold this point (see page 35).

2a) This is the model after creating the first squash fold.

3) The squash fold produces a square in that corner of the paper. Valley fold the two inside edges to the center diagonal crease line of the square.

4) Mountain fold the tip back behind the model and unfold the folds you made in step 3.

5) Petal fold the flap up. (See page 83.)

6) Now repeat steps 1–5 on the remaining three points of the windmill base. The model will now resemble a four-pointed star.

7) Make a second four-pointed star and join them back to back. To join the two, hook the four small triangles on the back of each star around the body of the other star.

8) Lift the small triangular flaps up.

9) Then bring the two stars together back to back and refold.

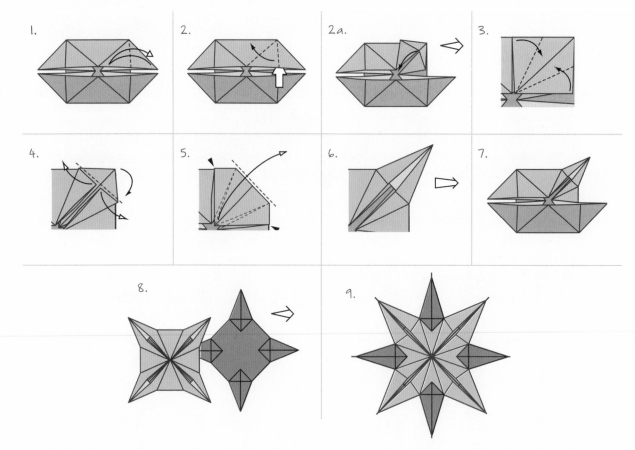

1.

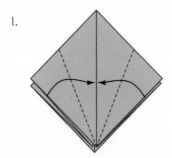

2.

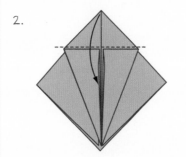

3.

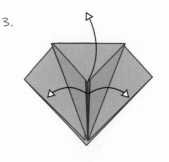

4.

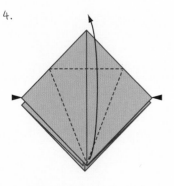

5.

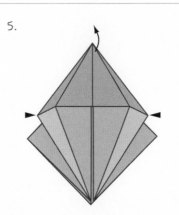

6.

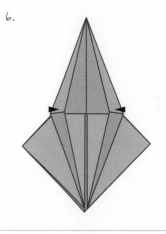

PETAL FOLD

1) Valley fold the right bottom edge to the center vertical crease line. Valley fold the left bottom edge in, too.

2) Valley fold the top point straight down.

3) Unfold the folds you made in steps 1 and 2.

4) Take hold of a single layer of paper and slowly lift it up. As you lift, let the paper hinge along the horizontal crease you made in step 2.

5) Like the petal of a flower, the sides will want to fold in toward the center (notice the black arrowheads). Let the sides fold in along the crease lines made in step 1. Help guide these side flaps into place. The crease lines leading to the top point will need to change direction.

6) Continue lifting the point until the paper lies flat.

7) This is the finished fold.

7.

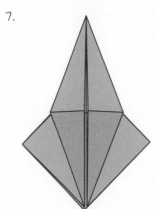

the four-pointed star

As with the Eight-Pointed Star, you may contemplate the essence of the star quality in your own life. What lights you up? Does stargazing give you a sense of awe at the vastness of the universe? Continue to bring your awareness back to the brightness in your own life as you practice folding an origami four-pointed star.

The Four-Pointed Star is also great for decorating gifts or hanging on the Christmas tree. This is a perfect holiday craft!

NOTE: The Four-Pointed Star introduces the **bird base**.

Build the
BIRD BASE

1) Begin with the preliminary base (see the Sailboat, page 73). Valley fold a single point in from the left. Its bottom edge should lie along the center crease line. Do the same with the right point.

2) Valley fold the top point straight down.

3) Unfold the folds you just made in steps 1 and 2.

4) Using the crease lines made in steps 1 and 2, make a petal fold (see page 83).

5) Turn over.

6) Repeat steps 1–5 on this side of the model.

7) This is the bird base.

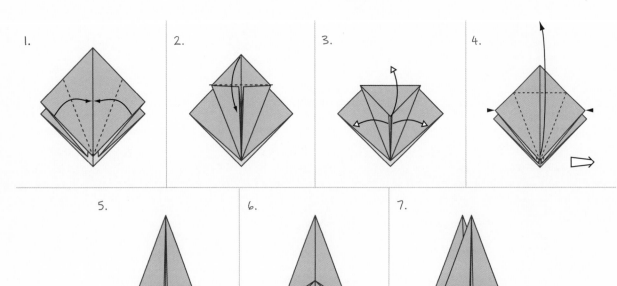

Complete the Model

1) Valley fold a single point from the right to the left.

2) Valley fold a single bottom point up to the top point.

3) Turn over.

4) Valley fold a single point from the right to the left.

5) Valley fold the bottom point to the top point.

6) Valley fold the bottom right-hand point (just one) so that its bottom edge lies along the center vertical line. Do the same for a left-hand point.

7) Turn over.

8) As in step 6, valley fold the bottom right and left points to the center vertical line.

9) To open the star, place your thumbs between the front and back layers. Hold the bottom triangular flaps in with your pointer fingers. Now open the star by turning your wrists so the palms turn upward. The inside center of the model will offer a little bit of resistance, but it will eventually open and lie flat. Once you have opened the star far enough, press it flat.

10) This is the finished model.

1.

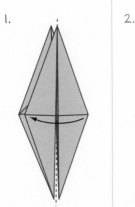

2.

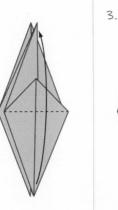

3.

4.

5.

6.

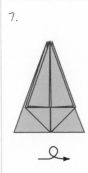

7.

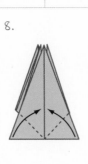

8.

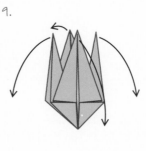

9.

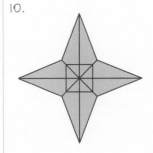

10.

the flapping bird

The traditional Flapping Bird is a simple variation on the Peace Crane (the next model) that continues to delight many people, young and old alike. The charming feature of this model is that it seems to come alive. By pulling gently on the bird's tail, you can make the wings flap. Your bird will spring to life!

As Ted Andrews writes in *Animal Speak*, "Birds have an ancient mythology and mysticism. In most societies, animals were visible signs of invisible forces, and people realized that you could only understand the Divine through its creations. This was especially true of birds."

As you fold your origami Flapping Bird, you may contemplate the mysticism embodied in all kinds of birds. While folding, you may continue to draw your awareness to your breathing, and to your contemplation of mysticism in your own life.

1) Begin with a bird base (see page 86). Valley fold the bottom right point up. The bottom right edge will touch the right corner of the diamond. Be sure the crease you make begins at the center.

2) Unfold.

3) Make an inside reverse fold along the existing crease lines (see inside reverse fold, page 55).

4) Valley fold the bottom left point up. The bottom left edge will touch the left corner of the diamond. Be sure the crease you make begins at the center.

5) Unfold.

6) Make an inside reverse fold along the existing crease lines.

7) To make the head of the Flapping Bird, valley fold the top right point forward and crease.

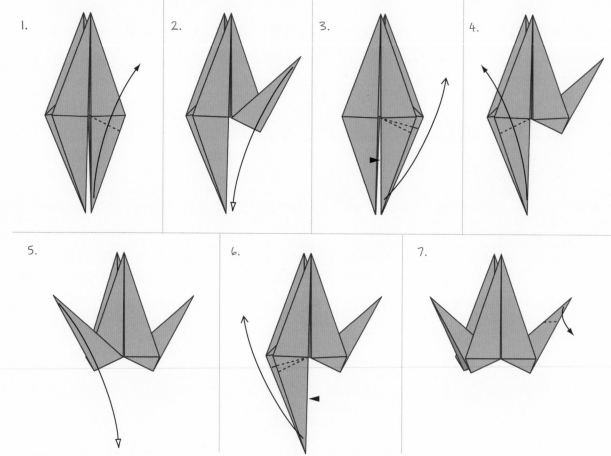

1.

2.

3.

4.

5.

6.

7.

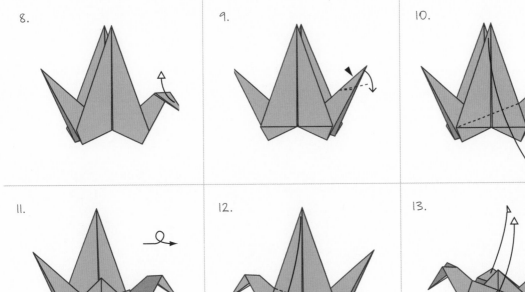

8.

9.

10.

11.

12.

13.

8) Unfold.

9) Inside reverse fold the tip along the existing crease lines.

10) Valley fold the front wing forward and crease.

11) Turn over.

12) Valley fold the other wing forward and crease.

13) Unfold both wings.

14) To make the bird's wings flap, let the wings hang open slightly. Hold the bird with two hands, one at the base of the neck and one at the tip of its tail. Pull the tail up and down and your bird's wings will flap.

14.

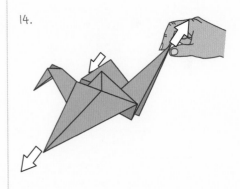

the peace crane

In Japan, animals often have symbolic meaning. The crane is the symbol for long life and good health. As mentioned in the Introduction, the crane has also become a symbol of peace. This traditional crane model has wings that stick straight out to each side. It is one of the earliest examples of a three-dimensional model in origami.

As you fold your origami crane, envision the many ways you may create peace and cultivate harmony in your life.

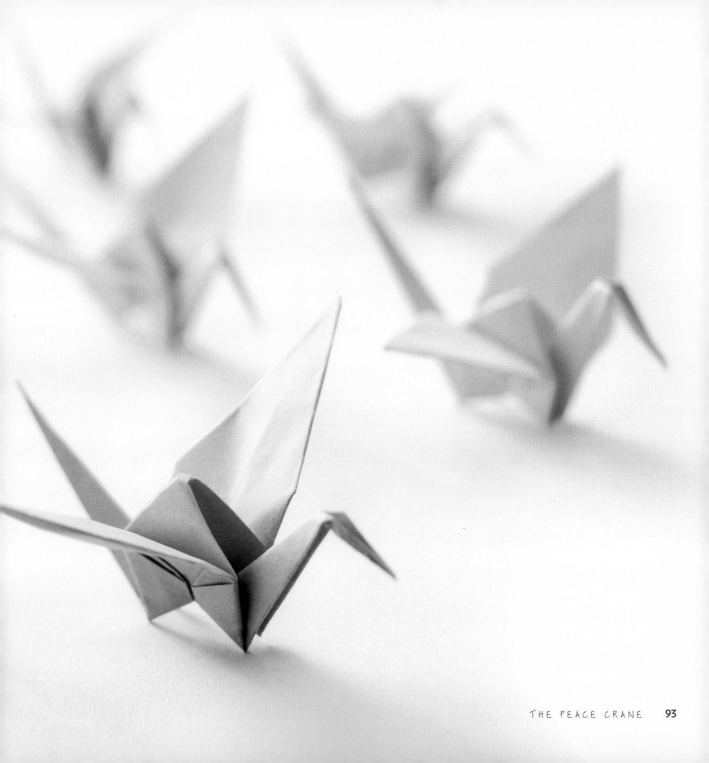

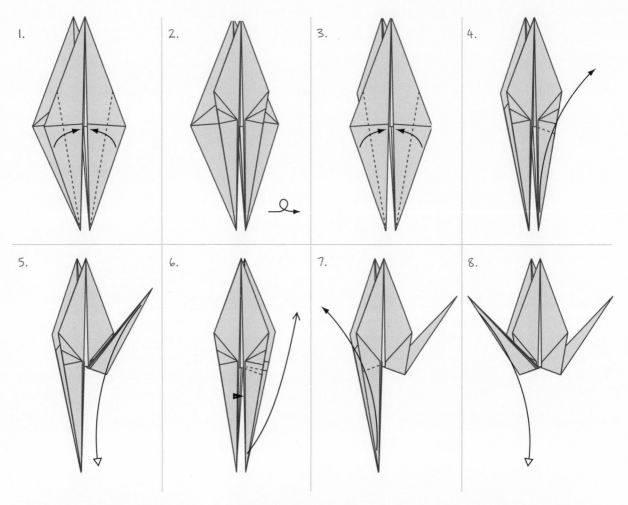

1) Begin with a bird base (see page 86). Valley fold the bottom right edge to the center vertical line and crease. Valley fold the bottom left edge to the center vertical line and crease.

2) Turn over.

3) Valley fold the bottom right edge to the center vertical line and crease. Valley fold the bottom left edge to the center and crease.

4) Valley fold the bottom right point up and crease.

5) Unfold.

6) Make an inside reverse fold along the crease lines you just made (see inside reverse fold, page 55).

7) Valley fold the bottom left point up and crease.

8) Unfold.

9.

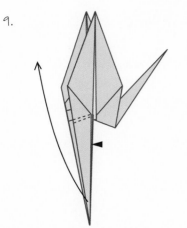

10.

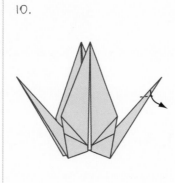

11.

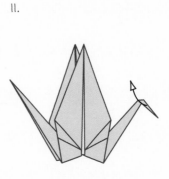

12

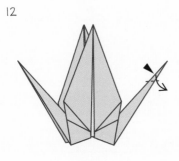

13.

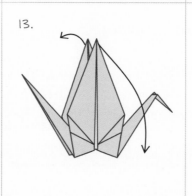

14.

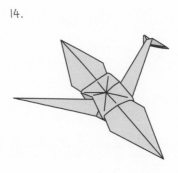

9) Make an inside reverse fold along the crease lines you just made.

10) Now return to the front point and valley fold the tip forward. This will become the head of the crane.

11) Unfold.

12) Make an inside reverse fold along the crease lines.

13) To open the crane's wings, place your thumb inside the wings and gently pull open. The inside point (the back of the crane) will open. Stop when the wings stick straight out.

14) This is the finished model.

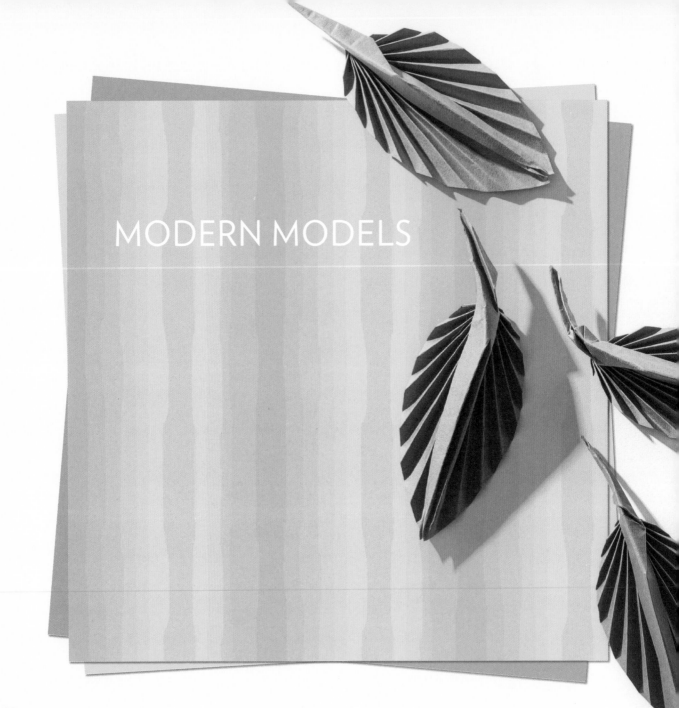

MODERN MODELS

the leaf

Maarten van Gelder designed this leaf. Unlike the traditional models in this book, the Leaf uses pleat folds to create a teardrop-shaped object. This version of the leaf uses eight pleat folds, but you can create the Leaf using as many as thirty-two folds. Folding the model is not difficult, but it does require you to make your folds as precise as possible.

A leaf is symbolic of the essence of nature. When folding your origami leaf with mindful awareness, you may reflect on your relationship with the natural environment. As you fold, continue to contemplate the essence of nature, drawing your attention back to the present moment in a nonjudgmental way.

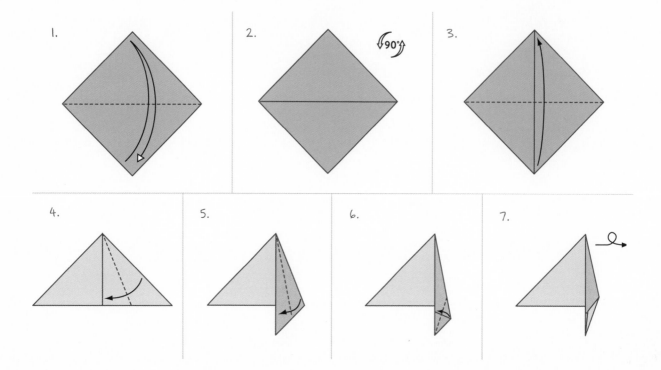

1) Begin with the colored side of the paper facing up and a corner pointing toward you. Valley fold the bottom corner to the top corner. Crease and unfold.

2) Rotate the paper 90 degrees.

3) Valley fold the bottom corner to the top corner and crease.

4) Valley fold the right edge of the triangle so that it lies along the center vertical crease line. Crease.

5) Again, valley fold the top right edge so that it lies along the center crease line and crease. Be sure the crease meets at the top point.

6) Now valley fold the bottom right edge so that it lies along the center vertical crease line, as shown. Crease.

7) Turn over.

8.

9.

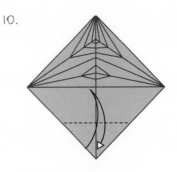

10.

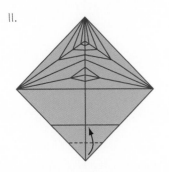

11.

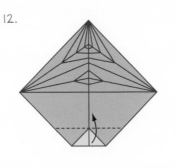

12.

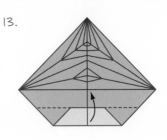

13.

8) Again valley fold the bottom left edge so that it lies along the center vertical crease. The paper is getting thick. Make the crease as best you can and press the paper flat.

9) Gently unfold the full square of paper.

10) Position the paper so that the colored side is facing up, the crease lines are at the top, and a corner is pointing toward you. Valley fold the bottom corner to the center of the square. Crease and unfold.

11) Valley fold the bottom corner to the crease line you just made. Make sure the point is right where the horizontal and vertical crease lines meet. Crease.

12) Valley fold along the existing crease line.

13) Valley fold the bottom edge to the center horizontal crease line and crease.

(continued on page 100)

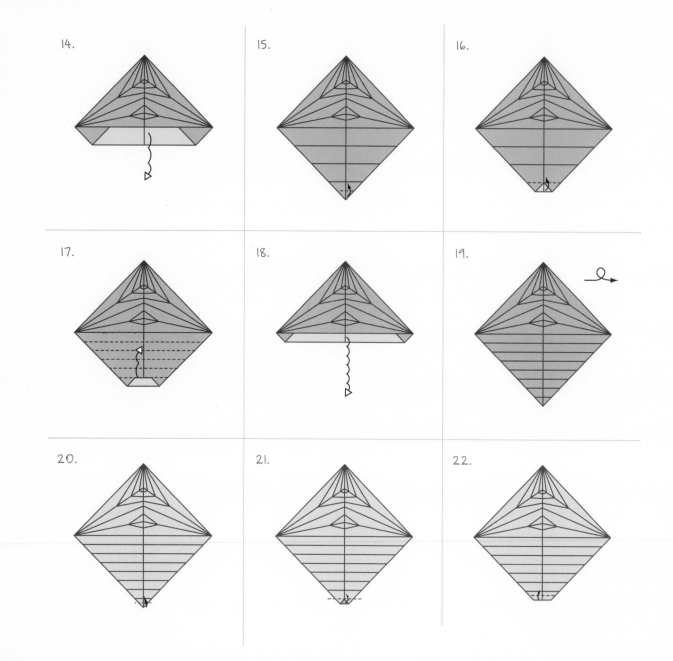

14.

15.

16.

17.

18.

19.

20.

21.

22.

14) Unfold.

15) Valley fold the bottom corner to the first crease line.

16) Valley fold along the existing crease line.

17) Continue folding in this manner until you reach the center crease line.

18) Unfold to the square again. There should now be seven horizontal crease lines between the bottom corner and the center horizontal line.

19) Turn over.

20) Valley fold the bottom corner to the first crease line.

21) Mountain fold along the existing crease line.

22) Valley fold the bottom edge to the next crease line.

23) Notice the fan shape you are creating. Continue this until you reach the center crease line. Keep the vertical crease line lined up as best you can.

24) When you have finished pleating the paper mountain, fold one corner to the other. The pleats you make will fan

open into a teardrop shape. Do not pinch them closed, but let them open. Now, rotate the model 90 degrees.

25) From here on, you will need to pick the paper up and fold the model in the air without using the table.

26) Now repeat steps 4–9, this time holding the model in your hand instead of flat on the table.

27) To help the stem stay together, give it a slight curl by rolling it around your finger.

28) This is the finished model.

23.

24.

⇗90°⇖

25.

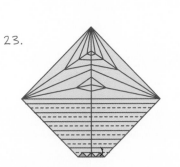

26.

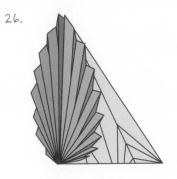

27.

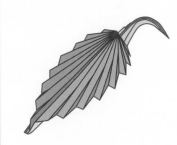

28.

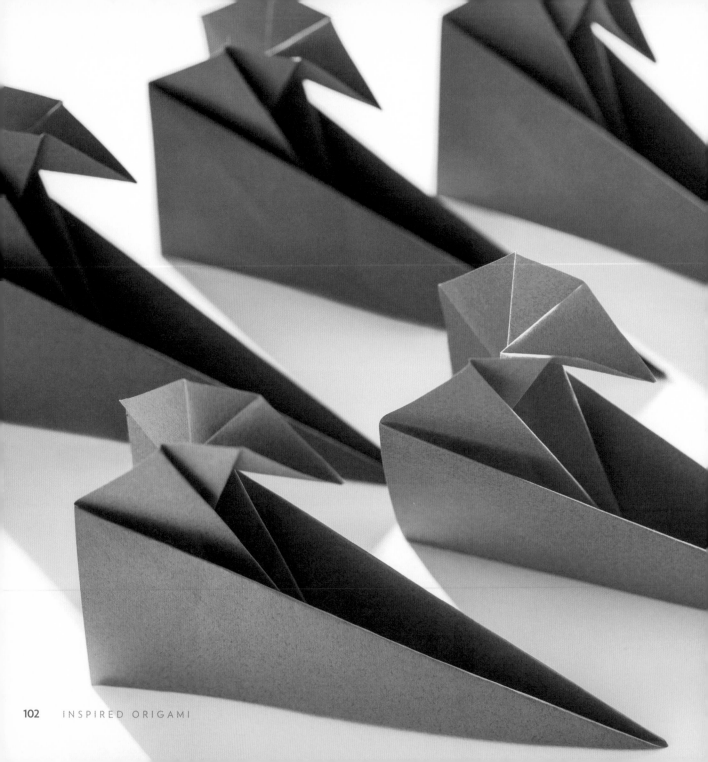

the wave

This Wave, designed by Thomas Hull, requires numerous inside reverse folds, a fold with which you should now be very familiar. The challenge in folding this piece is in making sure your folds are exact and your creases sharp. The Wave requires you to precrease the model (steps 1–10) and then fold along the existing crease lines (steps 11–16).

As one of the pioneers of bringing mindfulness to the West, Jon Kabat-Zinn writes, "You can't stop the waves, but you can learn to surf." You may practice mindfulness while folding your origami Wave, and contemplate the waves of life. Consider practicing mindfulness as a way of learning to surf your experience of daily life, including whatever thoughts, feelings, or reactions that may arise.

1) Begin with the colored side of the paper facing up and a corner pointing toward you. Valley fold the bottom corner to the top corner and crease.

2) Rotate the triangle so the left point is now facing toward you.

3) Valley fold the long diagonal edge so that it lies on the top edge. Crease and unfold. Note where this crease line meets the left edge. This point is a reference point for the next fold.

4) Valley fold the bottom point straight up. Make sure the crease you make begins at the reference point (where the crease line from the previous step meets the left edge). Crease sharply and unfold.

5) Notice that below the horizontal crease line you just made is a smaller triangle that looks exactly like the larger triangular sheet of paper. In the next few steps, you are going to repeat steps 3 and 4 within this smaller triangle.

6) Valley fold the right diagonal edge to the top of the smaller triangle (the horizontal crease line). Crease and unfold. Where the new crease line touches the left edge is the reference point for the next step.

7) Valley fold the bottom point straight up. Make sure the crease you make begins at the reference point (where the crease line from the previous step meets the left edge). Crease and unfold.

8) Again, notice the even smaller triangle. In the next few steps, you will be repeating the same two folds one more time.

9) Valley fold the diagonal edge to the top of the smaller triangle. Crease and unfold. Where the crease line meets the left edge will be the reference point for the next step.

10) Valley fold the bottom point straight up so the crease you make begins at the reference point (where the crease line from the previous step meets the left edge). Crease and unfold. (If you choose, you can continue these two steps again and again on the smaller and smaller triangles.) Rotate the model clockwise 45 degrees.

11) Go back to the first crease you made in step 3. Valley fold the front flap forward and mountain fold the back flap behind. Crease both.

12) Using the next crease line as a reference, make an inside reverse fold along the crease lines (see inside reverse fold, page 55).

13) Inside reverse fold the next crease.

14) Inside reverse fold.

15) Inside reverse fold.

16) Inside reverse fold.

17) This is the finished model.

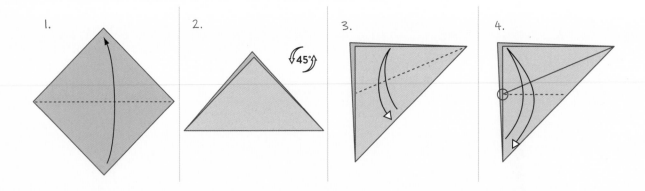

1.

2. ⟨↓45°↑⟩

3.

4.

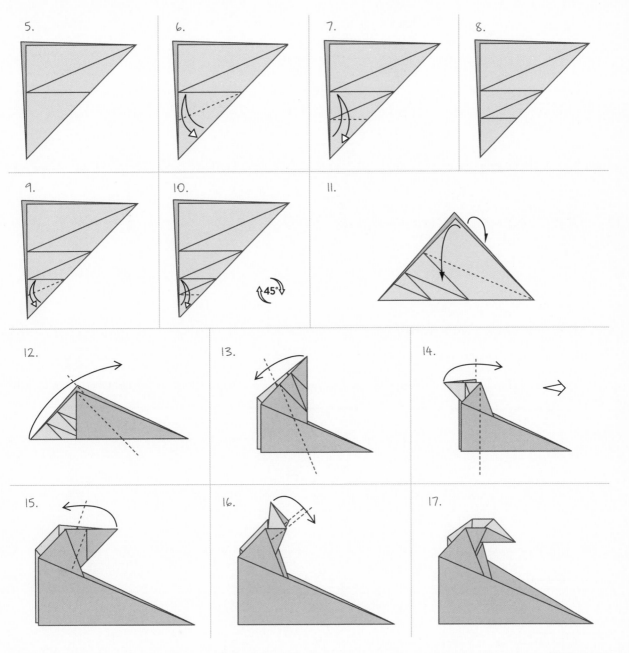

the candy dish

This Candy Dish is one of my own origami creations. To fold this model, you need to be proficient at folding pleats (introduced with the Fancy Box, page 56, and the Leaf, page 97) as well as inside reverse folds. Take your time when folding the Candy Dish and make each fold as accurate as possible. Remember, neatness counts!

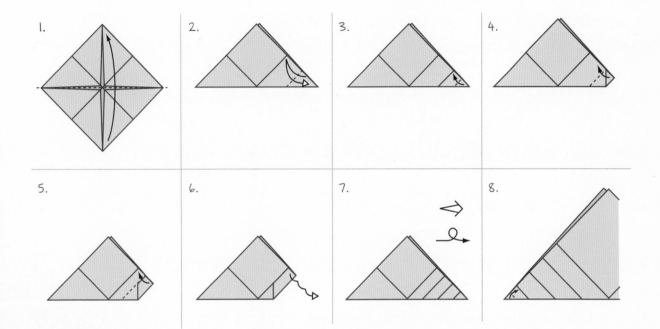

1) Begin with a blintz base (see page 57). Position the paper so that a corner is pointing toward you. Valley fold the bottom corner to the top corner and crease.

2) Valley fold the right point of the triangle to the crease line halfway up the side. Crease and unfold.

3) Now valley fold the same point to the crease line you just made and crease.

4) Valley fold along the existing crease line.

5) Valley fold the edge to the next crease line.

6) Unfold to the triangle.

7) Turn over.

8) Valley fold the left point of the triangle to the first crease line.

(continued on page 108)

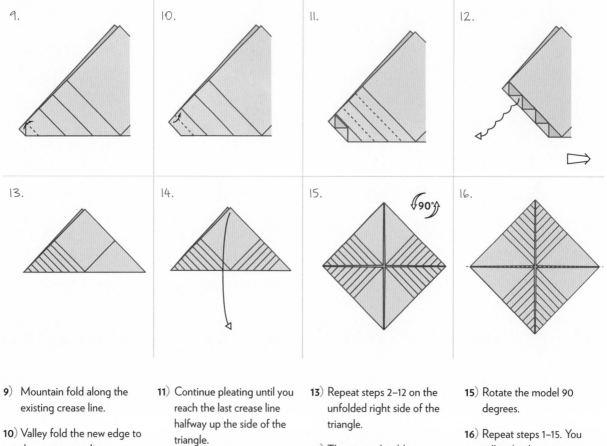

9) Mountain fold along the existing crease line.

10) Valley fold the new edge to the next crease line.

11) Continue pleating until you reach the last crease line halfway up the side of the triangle.

12) Unfold to the triangle.

13) Repeat steps 2–12 on the unfolded right side of the triangle.

14) The paper should now contain numerous crease lines. Unfold.

15) Rotate the model 90 degrees.

16) Repeat steps 1–15. You will make the same crease pattern in the left and right corners of the paper.

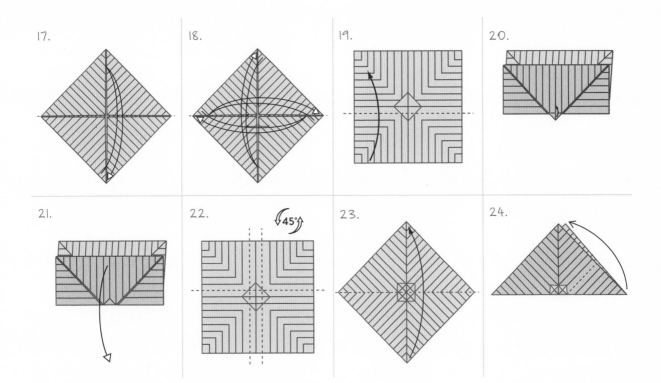

17) Notice that the paper has V-shaped creases in the top half. Bring the bottom corner up to the bottom of the second V crease from the top. When you crease the bottom, crease only between the three points shown.

18) Repeat step 17 on the remaining three corners. Turn the model over and rotate the paper so that an edge is now facing you.

19) Valley fold the bottom edge to the second horizontal crease line from the top. The valley fold falls on an existing crease line that will help you to make this fold. Crease along the entire length of the model.

20) A small triangular flap will stick out at the bottom. Valley fold this up.

21) Unfold the fold made in step 19. Do not unfold the small triangular flap.

22) Repeat steps 19–21 on the remaining three sides. Now you've finished precreasing the paper. Let's start folding. Rotate the model 45 degrees, so a corner is now pointing toward you.

23) Valley fold the bottom corner to the top corner and crease.

24) Inside reverse fold the right point of the triangle. The fold is made along an existing crease line.

(continued on page 110)

25. 26. 27. 28.

29. 30. 31.

25) Inside reverse fold the same point back out along the next crease line. The fold is not shown in the diagram because it is hidden by the top layer of paper.

26) Continue inside reverse folding along the existing crease lines until you have reached the end point of the triangle.

27) Repeat steps 24–26 on the left side.

28) Pick the paper up from the table. The model will no longer lie flat, and you will have to do all remaining folds in the air. Bring the two pleated corners together and turn the model so that you are viewing it from the side. If you look down into the dish, you will see the bottom square.

29) Repeat steps 24–27 on the left and right points. Take your time. These inside reverse folds are not easy to do.

Be sure to pinch along each fold so that they hold their shape.

30) Finally, gently pinch down each of the four sides of the dish. Press the bottom center square so it lies flat, and open up the four small triangles on the bottom of the model. These flaps will help the model stand.

31) This is the finished model.

resources

Congratulations! You are now an experienced paper folder. Amaze your friends with all you've learned. But remember, this book is only an introduction to the art of origami. There are numerous origami models in existence. You have just scratched the surface! If you are serious about learning more about origami, you may want to get involved with a local club or organization.

BOOKS

Biddle, Steve. *Essential Origami*. New York: St. Martin's Press, 1991.

Biddle, Steve, and Megumi Biddle. *New Directions in Origami*. New York: St. Martin's Press, 1993.

Engel, Peter. *Origami from Angelfish to Zen*. New York: Dover Publications, Inc., 1989.

Gross, Gay M. *The Origami Workshop*. New York: Michael Friedman Publishing Group, Inc., 1995.

Hunter, David. *Papermaking: The History and Technique of an Ancient Craft*. New York: Dover Publications, Inc., 1978. (This book is solely about the art of papermaking.)

Neale, Robert, and Thomas Hull. *Origami, Plain and Simple*. New York: St. Martin's Press, 1994.

Temko, Florence. *Paper Pandas and Jumping Frogs*. San Francisco: China Books & Periodicals, Inc., 1986.

———. *Origami Magic*. New York: Scholastic, 1994.

glossary

A

Action model A model that contains appendages, like wings or a mouth, that move when manipulated. Action models are complete only when their "action" is being demonstrated.

B

Base A sequence of folds at the beginning of an origami model that is the same for multiple origami figures. **See also** individual bases by name.

Bird base A specific base that lends itself particularly well to bird models because of the five flaps it creates in the paper: two for the bird's wings, one for its head, one for its tail, and one for its body. The bird base is introduced on page 86.

Blintz base A specific base that gets its name from the thin "blintz" pancake filled with cottage cheese and wrapped shut by bringing its corners together. The blintz base is complete when all four corners of the model are brought into the center and creased. It is introduced on page 57.

D

Diagram An origami illustration that communicates how to create a finished model. To make the folding process easier to comprehend, standard symbols and diagrammatic notations are necessary. These symbols make the diagram easy to comprehend without additional instructions.

F

Fish base A specific base made from two rabbit ear folds. It is an excellent base from which to begin fish models because there are two endpoints for the head and tail of the fish as well as two fins. The fish base is introduced on page 50.

Foil paper A type of origami paper that is foil on one side (usually colored) and white paper on the other. Foil paper holds a crease very well but is difficult to unfold or reverse.

I

Inside reverse fold A specific combination fold used most often to create heads for birds. The inside reverse fold requires the origamist to open the front (or top) of the model and push the back of the top point toward the front. The top point will reverse itself so that the other side of the paper is showing. The inside reverse fold is introduced on page 55.

K

Kite base A specific base that gets its name from its obvious kite shape. It is the simplest of bases and is introduced on page 42.

M

Modular origami The interlocking of multiple origami pieces (units) to form a larger and more detailed structure. The Eight-Pointed Star on page 80 is made from two sheets of paper and is a simple example of modular origami.

Mountain fold One of two basic folds in origami. To complete this fold, the paper is folded back away from the folder and creased. It is introduced on page 15.

O

Origami The ancient art of paper folding. The word itself is Japanese, from the words *ori*, to fold, and *kami*, paper. Practitioners fold sheets of paper into birds, fish, hats, and numerous other objects and forms.

Origami paper A thin, strong, square paper that is colored on one side and white on the other. Although any paper can be used for origami, this paper is specifically suited to folding because

it holds creases and yet unfolds and reverses easily.

Outside reverse fold A specific combination fold that is very similar to the inside reverse fold. To complete the fold, the folder must open the back (or bottom) of the model and wrap both sides of the point in question around to the front of the model. The outside reverse fold is introduced on page 44.

P

Papyrus An ancient writing surface made from the papyrus plant that grew along the banks of the Nile River.

Parchment A writing surface first developed in early 190 BCE to supplement Egyptian papyrus. It is made through a process of tanning and bleaching animal hides.

Petal fold A specific combination fold that gets its name from its resemblance to the opening of a flower petal. The petal fold is introduced on page 83.

Pleat fold A combination of alternating mountain and valley folds that resembles a fan. The Fancy Box, Leaf, and Candy Dish models use pleat folds.

Precreasing A technique in which crease lines are prefolded in the paper. Later folds are then folded along these precreased lines. Precreasing is often used to make a difficult or uncommon fold.

Preliminary base This base uses the same crease lines as the Waterbomb base, but in reverse. Instead of folding the center edges together, it brings the corner points together. The preliminary base is introduced on page 73.

R

Rabbit ear fold A specific combination fold that gets its name from its resemblance to a rabbit's ears. The rabbit ear fold is introduced on page 52.

Reverse fold See Inside reverse fold and Outside reverse fold.

S

Self-similar folds Recursive folds applied to progressively smaller and smaller portions of the paper. If you had small enough hands and an infinite amount of patience, you could continue folding forever, perpetually dividing the remaining paper. The Wave on page 103 uses self-similar folds.

Squash fold A specific combination fold in which a flap in the paper is squashed flat. The squash fold is introduced on page 35.

Symbol A core element of any origami diagram, symbols are used to indicate specific manipulations of the paper. A set of standard origami symbols is currently used all over the world.

T

Tuck fold A specific combination fold in which the paper is tucked into or behind another sheet of paper.

V

Valley fold One of two basic folds in origami. To complete this fold, the paper is folded toward you and creased. The valley fold is visually represented by a dashed line. It is introduced on page 15.

Vellum A specific form of parchment made from calfskin. See also Parchment.

W

Waterbomb base Named after the traditional Waterbomb, this base provides an excellent starting point for many models because of the four points it produces in the paper. The waterbomb base is introduced on page 64.

Windmill base A specific base that gets its name from the Windmill, a popular traditional model. The windmill base is introduced on page 38.

index

notes: